DRAWING IN INK

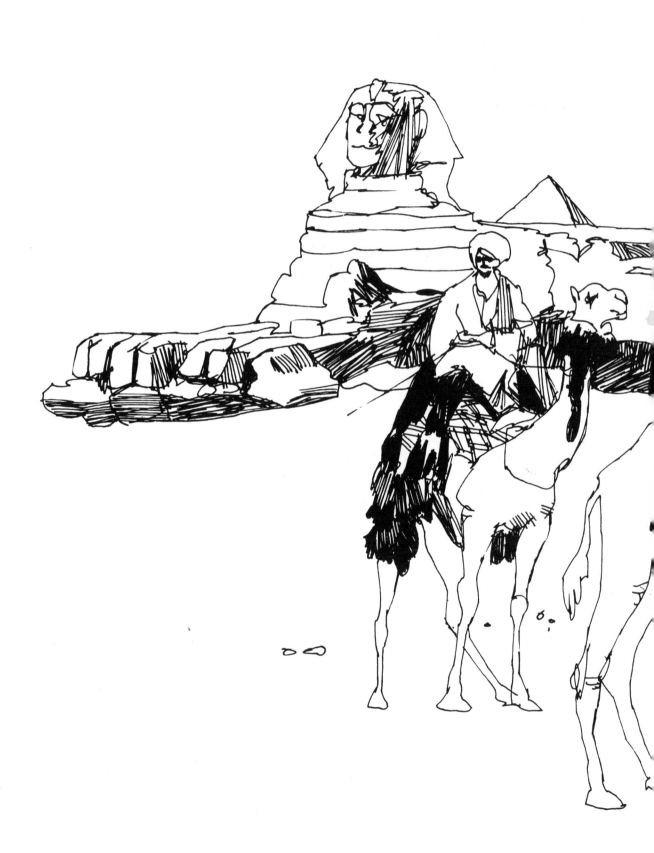

DRAWING IN INK

DRAWING FOR REPRODUCTION BY HARRY BORGMAN

WATSON-GUPTILL PUBLICATIONS/NEW YORK

Copyright © 1977 by Harry Borgman

First published 1977 in the United States and Canada by Watson-Guptill Publications
a division of Billboard Publications, Inc.
1515 Broadway, New York, N.Y. 10036

Library of Congress Cataloging in Publication Data
Borgman, Harry.
 Drawing in ink.
 Bibliography: p.
 Includes index.
 1. Pen drawing. I. Title.
NC905.B67 741.2'6 76-48153
ISBN 0-8230-1385-5

Manufactured in U.S.A.

First Printing, 1977
Second Printing, 1977
Third Printing, 1977
Fourth Printing, 1979

*To my best friend,
my wife Jeanne*

Contents

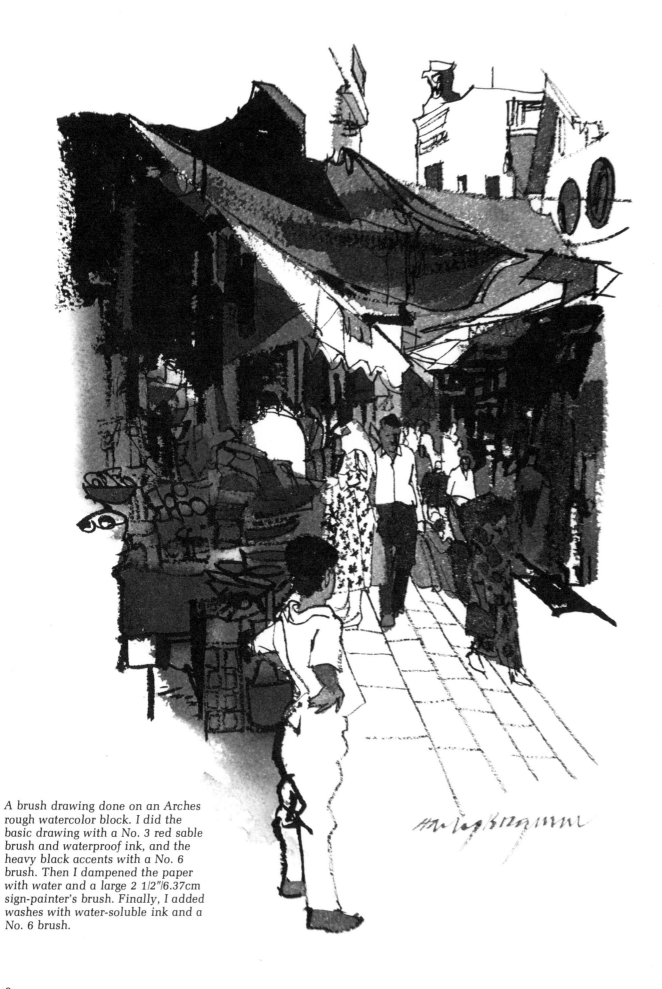

A brush drawing done on an Arches rough watercolor block. I did the basic drawing with a No. 3 red sable brush and waterproof ink, and the heavy black accents with a No. 6 brush. Then I dampened the paper with water and a large 2 1/2"/6.37cm sign-painter's brush. Finally, I added washes with water-soluble ink and a No. 6 brush.

Introduction

Ink is a fascinating medium—you work with simple materials that encourage bold, direct work. The limitations of ink compel you to eliminate the nonessentials, especially when doing simple outline drawings where the line becomes all-important. Working with line can actually help you develop your ability to see, and thus make you a better draftsman. Don't disregard the function of line—it will always be a part of your work and part of any artistic problem you encounter, whether in oil, watercolor, or ink.

A line can be many things—subtle, gentle, graceful, undulating, energetic, vigorous, and even agitated. Contour drawings, a form of line drawing, can suggest volume and mass as well as shape.

Before you get involved with rendering — whether in paint or ink—you need a good knowledge of basic sketching and drawing. For some artists, technique has become an end in itself. However, as important as technique can be, your first concern should be with actual drawing of the subject and its content. The problems of drawing are closely related to ink techniques, and ink rendering is one of many drawing techniques.

This book is not a basic how-to-draw book, but one that deals specifically with the technique of ink rendering. Its purpose is to familiarize both the beginner and developing artist with the characteristics of ink drawing in addition to various techniques and materials available. Thus there are many examples illustrating the great range of ink techniques, as well as several detailed exercises and demonstrations.

Many of the assignments I receive as an advertising illustrator are done in ink—and examples of my work are reproduced in the following chapters. I show graphically how I handle some of my assignments from the first rough sketch right through to completion.

Whenever possible, study the work of other artists in magazines, newspapers, and books — as well as in your local art museum and galleries. A great deal can be learned through observation. If you discipline yourself to practice the exercises in this book, you'll be on your way to mastering ink rendering techniques and styles.

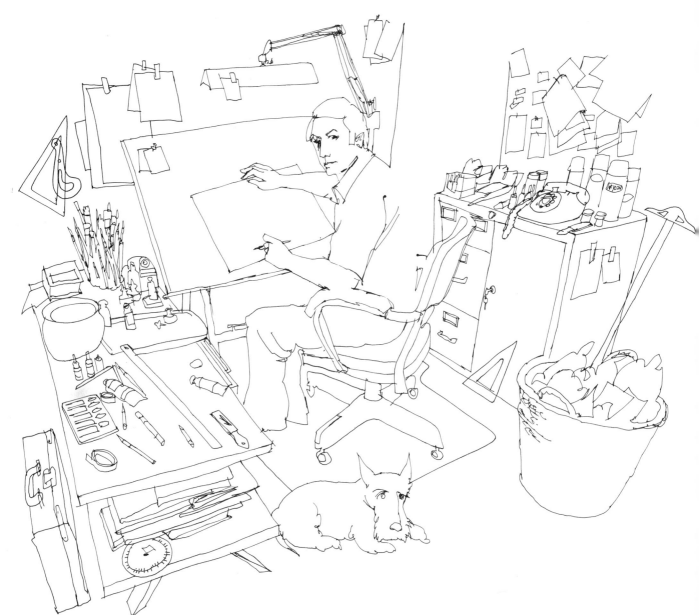

This is how my studio is set up—I think it's typical of most artists' studios. The large taboret on my left has four drawers for storing paints and other items and ample top surface which can be used to spread out needed tools or reference material. There's a large waterbowl for cleaning brushes, a porcelain enameled tray for mixing paint and washes, an electric pencil sharpener, and a revolving tray that holds pencils, brushes, and ink bottles.

The carrying case to the left of the taboret contains my Polaroid 180 camera, which I use a great deal for shooting reference photos. My drawing table in the center of the illustration has a counterbalanced board—I can adjust the tilt or height with my fingertips. The fluorescent lamp over the table is attached to a floor stand. The chair is a swivel type with casters, and sits on a Masonite mat for ease of movement. The cabinet to my right holds a picture reference file, business papers, camera equipment, and film. On its top is the telephone and other working tools. The cork wall behind the cabinet comes in handy for notes, messages, and quick sketches that I use later. Between the taboret and the wastebasket is my ever present friend Angus.

Chapter 1.

MATERIALS AND TOOLS

This chapter covers in detail the many tools and other materials you can use to draw with ink. The supplies range from a few simple, basic tools to innumerable kinds of highly specialized artist's paraphernalia.

If you're a beginner, all you really need to get started is a penpoint, such as a Gillott 659 crowquill or a Hunt 102 crowquill, a penholder, a bottle of waterproof ink—Artone, Higgins, Pelikan, Winsor & Newton, or Rapidograph are all of good quality—a No. 2 red sable brush, and a pad or a few sheets of bristol board. A small drawing board, about 20″ x 26″/50.8 x 66cm, would be helpful to tack the bristol board on. You can use the drawing board on a desk, at the kitchen table, or even outdoors when you sketch on the spot.

My advice to the beginning artist is to keep your supplies down to a bare minimum. Many beginners have a tendency to buy all kinds of interesting tools and drawing items, but it's not necessary to burden yourself with an expensive array of gadgets and highly specialized tools at this point.

TABLES AND LAMPS

As you progress, a more advanced setup might include an inexpensive drawing table that can be adjusted to different angles, enabling you to work in the position you find most comfortable. These tables are also adjustable for heights up to 40″/101.6cm, and the top working surface dimensions are usually 24″ x 36″/60.96 x 91.44cm or 31″ x 42″/78.74 x 106.68cm. There are some very good, inexpensive drawing tables available, as well as elaborate ones that are quite costly. In addition to this drawing table, you will need a small, compact table or taboret to set your tools on and for storage space. For seating, any chair will do, but many artists prefer a chair with armrests that swivels and has casters for ease of movement.

A small fluorescent lamp that you can attach to your drawing table is a nice luxury if you can afford it. Good light is very important for drawing, and the fluorescent lamps have the advantage of providing a very bright, uniform light that casts soft shadows.

SKETCHING MATERIALS

You may want to sketch your drawings in advance. In that case, you'll need a pad of tracing paper and some good drawing pencils, such as Eagle Turquoise, Koh-I-Noor, Mars Lumigraph, and Venus. A few brands have an eraser on the end, which I find convenient. All drawing pencils use a grading system indicating the hardness of the leads, ranging from 9H, extremely hard, to 6B, very soft. Faber-Castell has an even softer grade, 8B. Grades F, H, and HB are in the middle range. I prefer the HB for most of my general work and a 2H for drawing on a plate-finish board. You can sharpen the pencils with a standard pencil sharpener, or you can use an X-acto knife and shape the point with a sandpaper block. Erasers — Artgums, Pink Pearls, and kneaded rubbers — will all be helpful for cleaning up artwork.

Many fine brands of drawing pencils can be used with pen and brush drawings. The third pencil from the right is the Stabilo All, which can be used on any surface including acetate or Mylar. To its right is a china marking pencil that can be used on most surfaces and is especially well suited for drawing on Coquille textured boards. The pencil on the far right, Korn's litho crayon, is similar to the china marking pencil and is good for most surfaces. Below the pencils are erasers, from left to right: Cardinell Opaline for general use; Pink Pearl for use on tracing paper and illustration boards; kneaded rubber eraser for general use, for erasing pencil sketches drawn on layout or tracing paper, and for shaping to a point to accurately erase small areas; Magic Rub, a vinyl eraser, for general use. Below these four erasers is the Blaisdell Klenzo in pencil form, which is excellent for erasing small areas quickly without smudging. At the bottom of the photograph is a sanding block that is most helpful for keeping a sharp point on the pencil when doing finely detailed work.

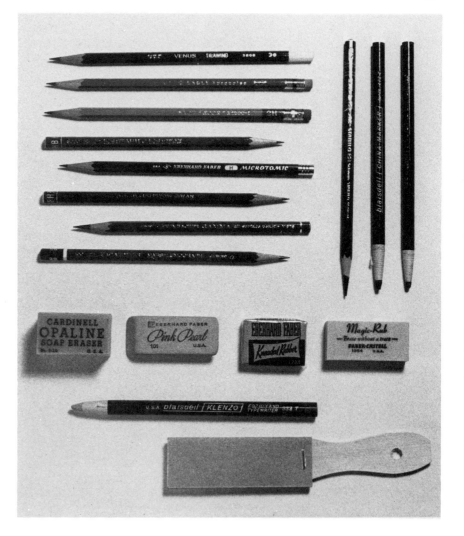

BRUSHES

When considering brushes for ink drawing, buy only the finest quality red sable brushes. A cheap brush simply will not hold up very long. Grumbacher, Robert Simmons, and Winsor & Newton all make very fine quality brushes. For adding gray wash tones to ink drawings with these brushes, I recommend water-soluble ink thinned with water. You should get a porcelain or plastic mixing tray to mix these washes, unless you want to use a dinner plate. You'll also need a small container for water to clean your brushes—and be sure to clean them after each use. Shake the brush vigorously in the water and wipe it clean with a rag. Every once in a while, wash your brushes in cold water with a mild soap.

You'll probably need three or four different pen holders, such as the ones on the left here. They come in a variety of shapes and sizes—just pick out the holders that feel most comfortable in your hand. Two or three brushes will be useful for doing ink drawings or adding washes to pen drawings. I recommend good quality red sable brushes, as they will allow more control and will last longer with proper care.

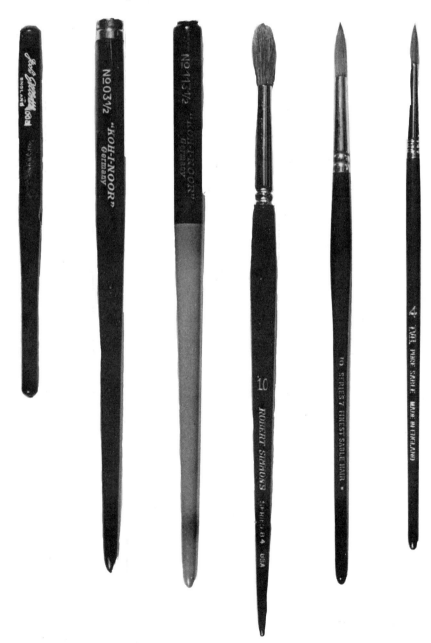

PENS AND ASSORTED TOOLS

There are a large number of pen points and holders available (see the chart Pen Points and Their Lines). Each point has a different range of flexibility and of line weight. Pick out a few and try them out until you find the ones that suit you best. Speedball pens, which are useful for lettering as well as drawing, come in a variety of shapes and sizes—style A has a square point, B a round one, C a flat tip, and D an oval tip. Felt pens and markers are really nice for sketching and drawing—Dri mark, Eberhard Faber Markette, Pentel, and Pilot are all good brands to use.

Technical pens are also very fine tools, as they contain their own ink supply. There are several brands to choose from, the most popular of which are Castell TG, Koh-I-Noor Rapidograph, Pelikan Technos, and Mars. I prefer the type that refills with a convenient cartridge, such as the Pelikan Technos. (The refillable cartridge comes in many colors besides black.) This pen has easily interchangeable points made of noncorroding alloy steel — it's a good general drawing tool, especially for outdoor sketching.

The Mars 700 series of technical pens also functions on the refillable cartridge principle, while the Mars 720 series has an automatic piston-action filling system. Both Mars pens are produced in a range of nine sizes, all color coded.

The Castell TG technical pen utilizes a drawing cone that has no screw-threading that can become encrusted with dried ink. The cone can be removed and replaced in seconds with a cone extractor for cleaning and refilling. Specially tempered, long-wearing, replaceable steel points are available in nine different sizes.

The Koh-I-Noor Rapidograph pen has its own automatic filling system—again, replacement points are available in nine different sizes and two styles.

You can purchase technical pens singly or in sets that include several pens and points. I recommend that you try out a couple of different brands before you invest in an expensive set. Each brand differs slightly in features or in operation—you'll have to decide which one you prefer.

PAPERS AND BOARDS

The many fine papers for drawing in ink are generally available in hot press, cold press, or rough surfaces. A hot press surface is smooth and is sometimes referred to as a plate or high finish surface. Its smooth surface is excellent for pen techniques, as the pen can glide over the surface without catching its point in a toothed texture. A cold press finish is versatile and has a medium-toothed surface that is suitable for pen, brush, pencil, paint, and washes. Rough surfaces are coarsely textured and more suitable for watercolor techniques than for highly detailed work.

Of course, all paper surfaces can be used for almost any purpose, your own imagination being the only limitation.

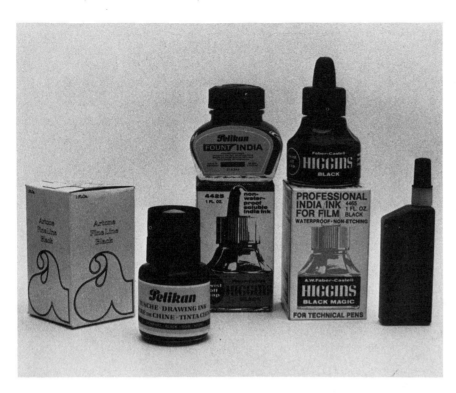

(Left) For general use, the best all-around ink is the regular waterproof, or India, ink. Special inks are made for technical pens, and there are extra-dense black inks for brushing in larger areas. Nonwaterproof inks are used primarily for washes over waterproof ink drawings.

(Below) Assorted tools, clockwise from bottom left: (A) compass; (B) ruling pen with an adjustable point; (C) Pelikan Technos technical drawing pen and its ink cartridge refill in a box; (D) stylus for tracing drawings or photostats on illustration boards; (E) marking pens for sketching and drawing—Pilot, Pentel, Design Art Marker, and Eberhard Faber Markette are shown here; (F) 4B graphite stick, excellent for bold sketches or for making a graphite tracing sheet to transfer drawings to illustration boards; (G) special tools for use on scratchboard; (H) complete set of Castell TG technical drawing pens.

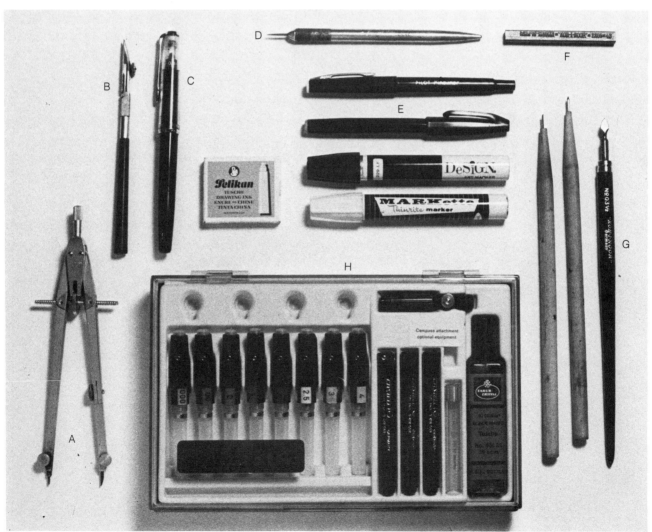

PEN POINTS AND THEIR LINES

Hunt 22, a fairly stiff point with a heavy basic line and a shallow range of flexibility.

Hunt 56, a stiff point with a heavy line and medium flexibility.

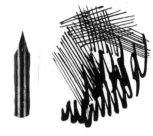

Hunt 99, a stiff pen capable of a wide range of line weight.

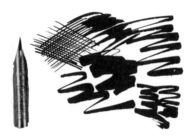

Hunt 100, an extremely flexible point resulting in an unbelievable range of line weight.

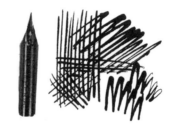

Hunt 101, a stiff pen with a heavier line weight and a limited range of flexibility.

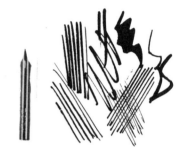

Hunt 102, a fairly stiff pen that still offers a good range of line weights and gives a nice fine line.

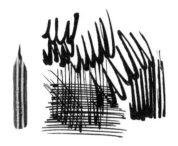

Hunt 103, a point that isn't as flexible as the 100 but has a great range in line weights.

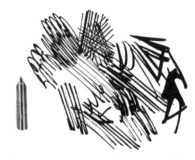

Hunt 104, a very stiff pen capable of drawing a very fine line.

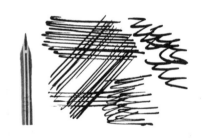

Hunt 107, a very stiff point with little range of line weight—excellent for drawing even lines.

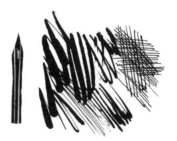

Hunt 108, an extremely flexible point with a superb range of line weights.

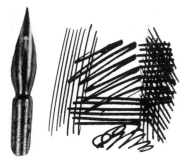

Hunt 513 EF, a good stiff point with a heavier line and a shallow range—véry good for drawing an even line.

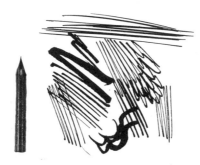

Gillott 659, a quite flexible point offering a great range of line weights as well as a nice fine line.

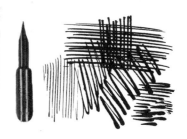

Gillott 1950, a stiff point with a limited range of flexibility—capable of drawing very fine lines.

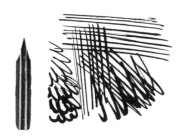

Gillott 303, a fairly stiff point with a heavier line and a limited range of line weights.

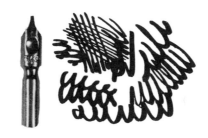

Wm Mitchell 0851, a stiff, flat-pointed lettering pen producing a heavy line in one direction and a finer line in the other.

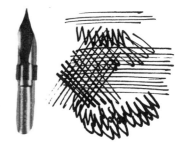

Wm Mitchell Script pen 0870, a stiff pen of little flexibility having an ink reservoir and drawing a thin even line.

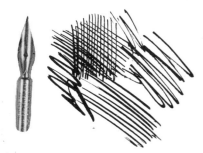

Iserlohn, a stiff point with a heavier line weight and a medium range of flexibility.

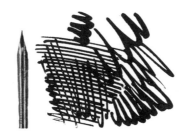

Iserlohn 515, quite a stiff point with a limited range of line weights.

Speedball A-5, a stiff point (with an ink reservoir) that draws a heavy, uniform line—there are many other points in this series in every size and weight imaginable.

Speedball LC-4, point made for left-handers for lettering—it is fairly flexible and offers a good range of line weights.

Experiment with all of them to learn how they respond to different pens, brushes, and ink. Also try illustration boards — fine quality papers mounted on stiff backing boards. They are easy to use because of their stiffness and come in lightweight, single-weight, and double-weight thicknesses. Illustration boards come in three sizes — 22" x 30"/55.9 x 76.2cm, 30" x 40"/76.2 x 101.6cm, and 40" x 60"/101.6 x 152.4cm. Bainbridge, Crescent, and Strathmore are all fine brands of both illustration boards and papers.

Bristol boards are 100% rag content papers available in plate or kid finish, the latter having a slight surface texture and the former a smooth one. The thickness of bristol boards is indicated by the term "ply," the number of plys being the number of sheets of laminated bristol. The weights range from 1–5 ply. Bristol boards are generally found in two sizes — 22" x 29"/55.9 x 73.66cm and 30" x 40"/76.2 x 101.6cm. Bristol is also available in conveniently bound pads 11" x 14"/27.94 x 35.56cm and 30" x 40"/76.2 x 101.6cm.

Of course, many fine quality papers—including rice papers—for printing, etching, block prints, and lithographs can be used for drawing in ink. Some of these special papers will be covered in detail in the following chapters.

DRAFTING TOOLS

At some point, you may want to buy a T-square and a triangle, both of which are useful for drawing horizontal and vertical lines and for squaring up drawings. You may also want French and ship curves for ruling curved lines with technical pens on mechanical drawings. Other drawing instruments, such as a ruling pen and ink compass, are very important to the advanced artist when drawing mechanical objects. You may find sets of drawing templates in circular and oval shapes, which enable you to draw perfect circles and ovals of varying degrees and sizes, a must.

Most of the items listed here are required only for very advanced work, but you should become familiar with what tools are available and how they are used. Many of these special tools are designed expressly for the convenience of the artist and to help the professional be more efficient. The following chapters contain many drawings executed with these tools and specific demonstrations that show in detail how the tools are used and the advantages they give the artist.

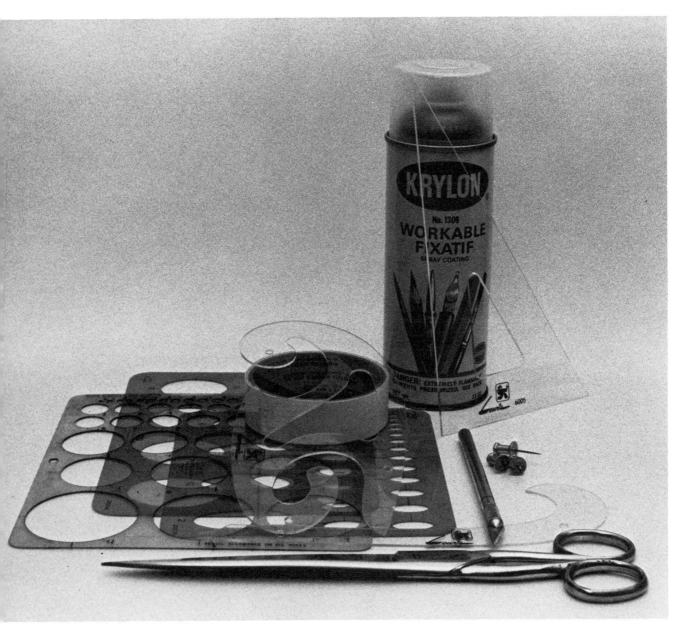

More drawing tools, from front to back: scissors; circle and oval guides and curves; X-acto knife; push pins; masking tape; triangle; and spray can of fixative to prevent pencil drawings from smudging.

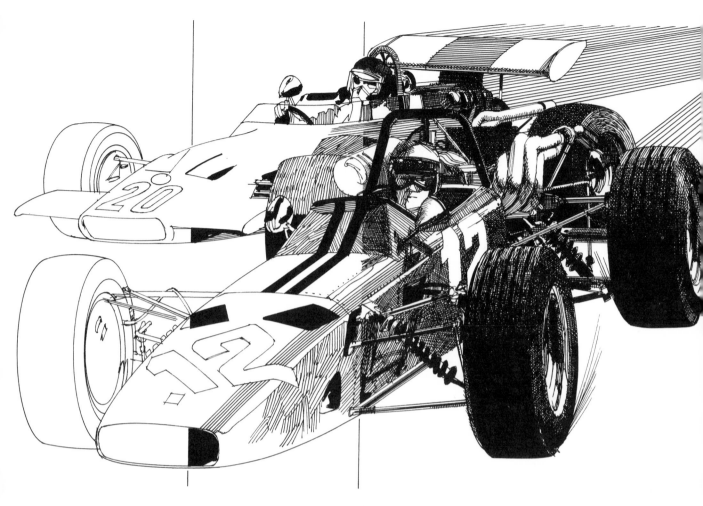

This is how I build up a line and tone drawing (from left to right): I first pencil in the drawing on the illustration board as a guide for the ink line, which I do in outline form in ink with a pen (here I used a technical drawing pen). Next, (moving to the right) I add the solid blacks with a No. 3 red sable brush. Adding the solid blacks is an aid for determining the gray tones—it gives me something to work against. After adding the blacks, I put in the very lightest linear gray tone. The intermediate tones are built up gradually until the drawing is finished (right half of the illustration).

The gray tones in this drawing incorporate many of the exercises discussed in this chapter. As you will see, this is a very simplified diagram of how an ink drawing is rendered—Demonstration 2 in Chapter 3 covers the process in complete detail.

Chapter 2.

PEN AND BRUSH EXERCISES

Drawing with a pen or brush may be difficult at first, but with a little practice you'll learn to control these tools and become familiar with their limitations and capabilities. Just as you learned to write the alphabet by practicing the formation of letters that make up words, you'll learn to draw by practicing lines and textures that in combination can represent specific objects. In addition, the combinations of drawn lines and textures that can represent objects, such as grass, wood, trees, or hair, communicate what they represent to the person viewing the drawing the same way a combination of written letters conveys words.

Drawing is really a matter of learning another way to see and of being able to interpret what is seen. Then you transform what you see — and what you've interpreted — graphically on paper through line and tone with a pencil, pen, or other tool. To do this, it's best to start by learning what the tools — here the pen and brush — are capable of doing. Each tool has certain advantages and limitations that you can become aware of only through practicing exercises like the ones in this chapter.

There are an extraordinary number of drawing styles and methods that you can use when drawing in ink. You can develop a very personal style, as distinct as your own handwriting. In fact, many artists have developed styles that are easily recognizable even when their drawings aren't signed.

It's very important that you practice drawing every day if possible — which is as often as you would practice if you were learning how to play the piano. If you do this, drawing with the pen and brush will come to feel very natural, as writing is now. And, as you become more familiar and comfortable with the tools, you'll gain the confidence that will help you to improve and grow as an artist.

The pen and brush have certain limitations that can be learned only by practicing on different illustration boards and paper surfaces. Certain boards have textures that can limit the freedom of your drawing strokes. While the pen may catch on the surface and cause a splatter on a rough surface, the brush will give you great freedom on this same paper. On the other hand, on a very slick and smooth surface, the pen will glide along with ease. I personally like to do pen drawings on a slightly textured surface—and being

conscious of the possibility of the pen snagging the surface, I tend to draw more carefully.

Most pen points offer varying degrees of flexibility, resulting in a wide range of line weights (see the chart on pages 16–17). Some points are extremely flexible and capable of a remarkable range of line weights, while others are very stiff, producing an even, uniform line. The technical drawing pen also produces an even line because its point is actually a small tube. Its great advantage is that you can draw in any direction on most surfaces without catching.

Brushes are also versatile drawing tools that offer a great variation in linear quality. With a well-pointed brush, you can draw both fine lines and bold lines — to draw a very bold line with this kind of brush, the brush must be fully loaded with ink. If this brush is flattened and used with a small amount of ink, it can create a unique dry brush effect.

The following exercises in this chapter are designed to help you to become confident in the use of the pen and brush. Try to practice at least one or two hours a day and you'll soon gain the necessary control of these drawing tools. This is your first step in becoming proficient with the pen and brush.

Exercise 1. Shapes and Lines

Practice drawing various shapes and lines—both fine and heavy as shown—on a piece of plate-finish bristol board with a crowquill pen. Since the plate-finish board is very smooth, the possibility of the pen snagging the surface is minimized. See what range of line weights you can produce with this particular point. Also try writing with the pen to loosen up. Draw both fast and very slowly, and notice the different line quality. Bear down lightly and then draw using more pressure on the pen point. Hold the pen in a variety of positions and take note of the different results. A little practice like this and you'll learn how the crowquill pen reacts to this particular paper surface. When you finish, try the same thing on other board and paper surfaces.

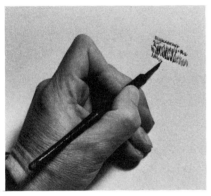

Here I'm using the crowquill pen as if I were writing. Note how many line variations and textures I am making while the pen is in this position— and try it yourself.

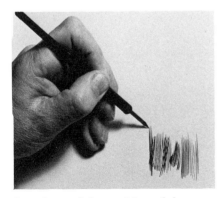

I've changed the position of the pen and therefore I'm producing a different kind of line. I'm stroking the pen sideways, quickly drawing a series of lines.

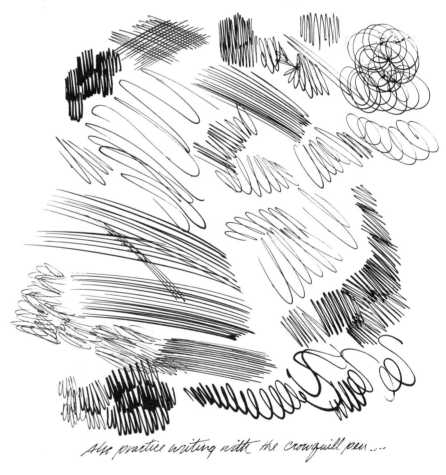

also practice writing with the crowquill pen....

Exercise 2. Lines and Textures

Practice drawing groups of lines and textures, such as the ones below, with first a pen and then a brush. Try a variety of pens and brushes to see how they differ.

Very quickly done; drawn with an even pressure.

Lines drawn slowly, moving the pen up and down slightly.

Same as above, but using more pressure on the point.

Lines of different weights drawn using a zigzag motion.

Lines drawn with a nervous motion and even pressure.

Drawn by varying the pressure on the point.

Lines formed by drawing short overlapping strokes.

Series of small loops.

Various dotted or broken lines.

Quickly drawn brush lines.

Slowly drawn brush line.

Zigzag brush line.

Line using more pressure on the brush tip.

Loose, short brushstrokes forming a scratchy line.

Brush line drawn with a nervous motion.

Split brush line.

Exercise 3. Pen Lines

Now concentrate on all sorts of pen lines, experimenting with spacing, pressure on the point, and curves. In the following nine groups of lines, draw the first lines (at the top or on the left of the square) straight, uniform, and evenly spaced. Draw the next lines closer together; the ones following as close to each other as possible without touching; next, nervous and scratchy lines; nervous, scratchy lines drawn with more pressure; and finally (at the bottom or on the right of the square) loose random lines.

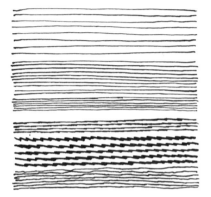

Horizontal lines.

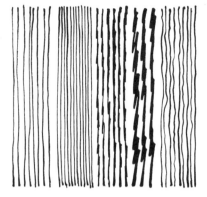

Vertical lines.

Varying the pressure on the point.

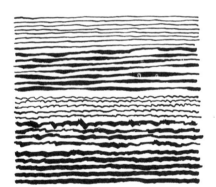

Controlling line weights.

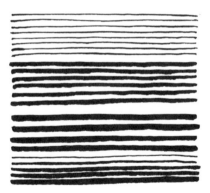

Lines of varying weights created by increasing pressure on the point.

Quickly drawn lines of different weights.

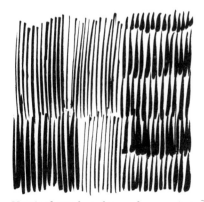

Vertical strokes drawn by varying pressure on the point.

Curved lines drawn slowly.

Curved lines drawn very quickly.

Exercise 4. Tonal Value with a Pen

Experiment with the pen again, exploring tonal value created by straight, crosshatching, and zigzag lines.

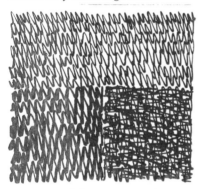

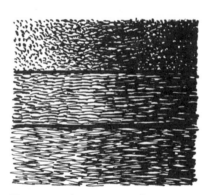

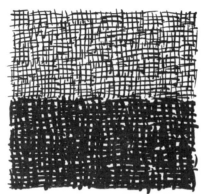

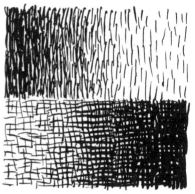

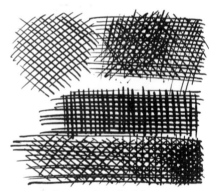

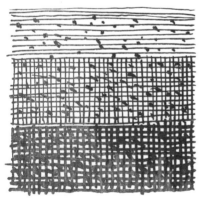

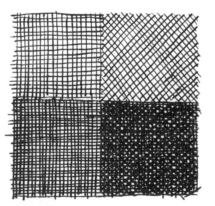

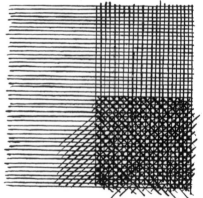

Top, a series of short, vertical strokes. Center, strokes drawn with more pressure. Bottom left, lighter lines drawn closely together. Bottom right, heavier lines drawn very close together.

Top, vertical strokes with horizontal lines drawn over them create a crosshatched effect. Bottom, heavy vertical and horizontal lines.

Top, lines drawn first close together and then gradually farther apart produce a gradation of tone. Bottom, a crosshatched tone gradation.

Top, up-and-down pen strokes drawn close together form a gray tone. Bottom left, a heavier zigzag line. Bottom right, zigzag lines crosshatched.

Top, very short pen strokes, graduated. Center, longer dash strokes, graduated. Bottom, zigzag lines, graduated.

Top left, crosshatched lines. Top right, crosshatched lines over the previous tone. Center, crosshatched lines drawn with more pressure. Bottom, graduated crosshatched lines.

Straight and crosshatched lines with dots drawn to create a different texture.

Top left, even crosshatching. Top right, 45° angle crosshatch. Bottom left, a heavier but even crosshatched line. Bottom right, the top right and left patches drawn a little heavier and over one another.

Lines ruled with a pen (see Exercise Five). Total square, lines drawn horizontally. Right, lines drawn vertically. Bottom right, two sets of lines at 45° angles.

Exercise 5. Ruling with a Pen and Brush

Ruling with the pen is a very useful technique. Try drawing first thin and then heavier lines by varying the pressure on the pen point — try to duplicate the lines illustrated below. After a while, use a brush—this is a little harder to do and you may find it quite difficult at first. Rest the ferrule of the brush against the ruler and very carefully draw a straight line, maintaining an even pressure on the point.

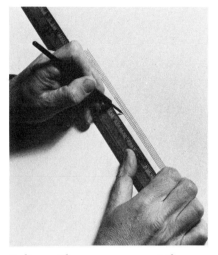

Ruling with a pen—you rest the pen against a ruler and carefully draw a line using an even pressure on the pen point. With a little practice, you'll gain the necessary control to draw in this manner. Please note that you can also do this with a brush instead of a pen.

Series of pen lines in an even tone ruled closely together.

Slightly heavier pen lines. More pressure is used, but it is maintained evenly.

Pen lines gradually drawn heavier. Very heavy ones made by overlapping.

Pen lines ruled by varying the pressure on the point.

Pen lines ruled using a nervous motion, creating a texture.

Series of lines in an even tone ruled closely together with a brush.

Slightly heavier brush lines, drawn with more pressure.

Brush lines gradually drawn heavier.

Lines ruled by varying the pressure on the brush point.

Brush lines ruled using a nervous motion, creating a texture.

Exercise 6. More Pen Lines and Textures

Here are some more combinations of lines and textures for you to practice. On the left is a series of graduated tones. With the white, the black, and the four grays in between, you can draw most anything—the white will be the paper or board. And, by varying the line weights, you can produce any number of intermediate gray tones.

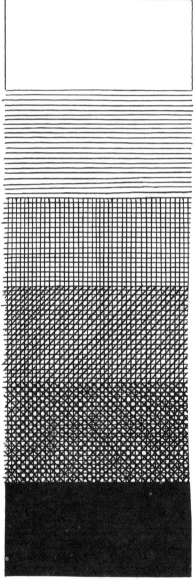

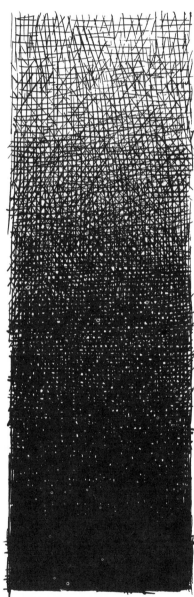

Ruled crosshatched pen tones of different values. From top to bottom: the white of the board; horizontal lines producing the lightest tone; vertical lines drawn over the horizontal ones to create the next darker tone; set of lines drawn over the first two sets at a 45° angle; lines drawn at a 45° angle from the other direction for the darkest tone; solid black.

Loosely drawn, random crosshatched lines graduated from light to solid black.

Top, graduated tone created by ruling lines of varying weight closely together. Bottom, short pen strokes graduating from light to solid black.

Exercise 7. Brush Lines

These brush exercises are the same as those suggested for the pen in Exercise 3. Practice them many times until you can do them with ease. Be sure to use a high quality red sable brush, Nos. 2 or 3, or you'll have problems. Cheaper brushes either won't maintain a good point or they'll split, making it impossible to draw fine lines.

Horizontal lines.

Vertical lines.

Varying the pressure on the point.

Controlling line weights.

Lines of varying weights created by increasing pressure on the brush point.

Quickly drawn lines of different weights.

Vertical brushstrokes drawn by varying the pressure on the point.

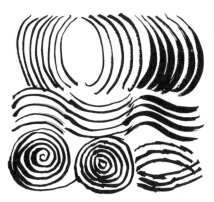

Curved lines drawn slowly.

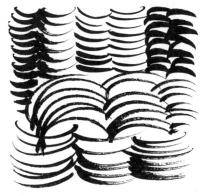

Curved lines drawn very quickly.

Exercise 8. Drawing Objects with a Pen

Make ink drawings of various objects around your house. Do careful, simple outline drawings at first, and try to use as few lines as possible. Study the object and visualize the lines that are important to explain the object graphically. As you may know, you can create a great deal of form with a line by paying attention to perspective and by drawing the right lines in front of one another. Line without tone can be a very effective technique if properly handled.

After doing a few very simplified outline drawings, try some that are more detailed—but still without tone. Next, do some drawings with shading. All of these drawings can be done with a pencil, Pentel, or Pilot felt pen if you wish, but I suggest using a crowquill pen, so you become familiar with its qualities and limitations.

I picked these objects—the candlestick, shoe, ink bottle, and jar—at random to demonstrate the kinds of drawings I mean. Pick out fairly simple objects at first like these, and later go on to tackle more complex subjects such as house plants or even outdoor scenes.

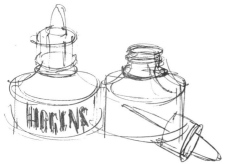

This sketch, of the ink bottles on my taboret, is very fast and loose. You should practice doing many drawings in this vein. Don't worry about drawing through objects and lines— this will help you understand form much better.

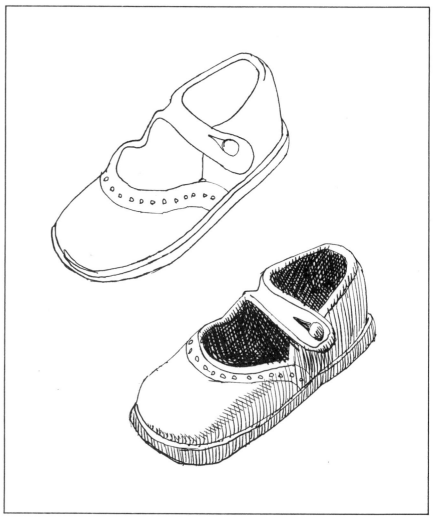

I did these shoes in two ways—the one on top is a simple linear representation, carefully done. The bottom version has a few simple tones added that create the illusion of form and depth.

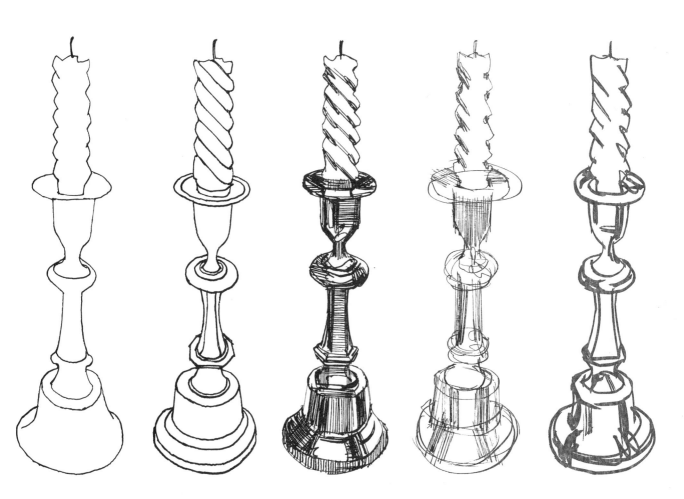

The candlestick at the left is drawn in very simplified form, devoid of any detail. Try to think in these terms for your first attempts—break everything down to bare essentials and draw using as few lines as possible. To the right of this candlestick is a very carefully done drawing in which all the important details are included. The center candlestick is a more advanced representation —even the shine of the metal is simulated. Moving to the right again is a very loose pen sketch. It takes a good deal of confidence in yourself and knowledge of your tools to be able to do very free direct sketches like this. When you do free drawings, don't be too concerned if a line here or there isn't quite in the right place. These are sketches, and some of the accidental qualities that result can enhance a drawing. The candlestick on the far right is a brush drawing done with a No. 3 red sable.

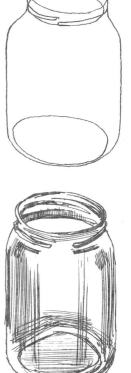

The jar on top is very simply yet fully rendered—but it takes just a few moments to do sketches like this. Neither of the jars is perfect (the ovals are off a little) but it really doesn't matter. Your drawings don't have to be perfectly accurate; if you feel you've made some major errors, just start over. Your next attempt will be much better. The important thing to remember is to do a lot of drawings of many different objects. This type of practice will be the foundation of your later work.

Exercise 9. Simplifying Drawings

A line drawing can be very effective and interesting without gray tones—interpreting objects only in line can be a real challenge. It isn't necessary to put all the lines in, either, as these drawings demonstrate. As you may know, simplifying drawings isn't always an easy task—it sometimes takes a great deal of planning to decide what lines to leave out of a drawing. These examples demonstrate the variety of ways textures and tones can be added and how different the drawings can look as a result.

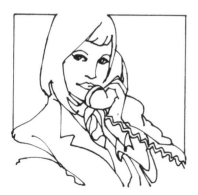

Notice how few lines are used to portray the girls. And the man's collar isn't even drawn in.

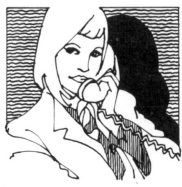

A simple, solid black is added—it makes a very effective combination with the line.

Stipple and dash lines are added —the dots in the background, fairly evenly spaced, create a flat tone.

Papers on the table break up the outside shape.

Three flat gray tones and black accents augment the outline.

An almost solid black version is very strong and dramatic.

Again, the outside shape is broken at the girl's head.

Two simple line tones and a strong black shadow are added.

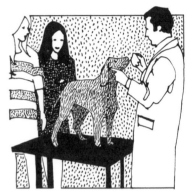

Ruled pen lines create the tone here—a brush adds accents.

Exercise 10. Interpreting Gray Values into Ink Line

This exercise will help you learn to interpret gray values into ink line. Take a black and white photograph — your own or one from a magazine — that is preferably of an outdoor landscape scene. Try to break the photo down into simple gray tones before making a line drawing of it. It's a good idea for you to actually do a few value breakdowns such as this of several photographs.

I used Winsor & Newton designers colors, black plus grays Nos. 1, 2, 3, and 5, for this example, though you could also use gray markers on layout paper. I frequently do marker sketches to solve value problems on complex ink drawings.

When you finish one of these diagrammatic value studies, set it next to the photograph and stand back to view them. If properly done, the gray toned sketch will be difficult to distinguish from the photograph.

Then go on and make your line drawing.

Photograph of a landscape.

Try to visualize the photograph broken down into simple gray tones and shapes—like the one I painted here. I don't do sketches like this for every drawing, but this is how I try to visualize every scene or object before starting.

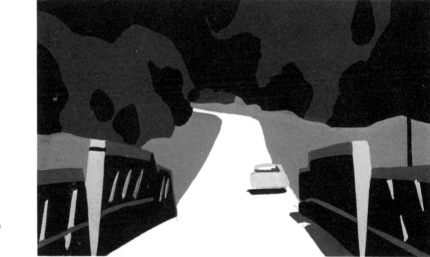

I left this ink line interpretation unfinished, so you can study how it was done. First I did a pencil drawing, and then I put in the light gray tone of the grass. Next, I added a darker background and the very dark areas. Finally, I added textures to the trees to simulate leaves.

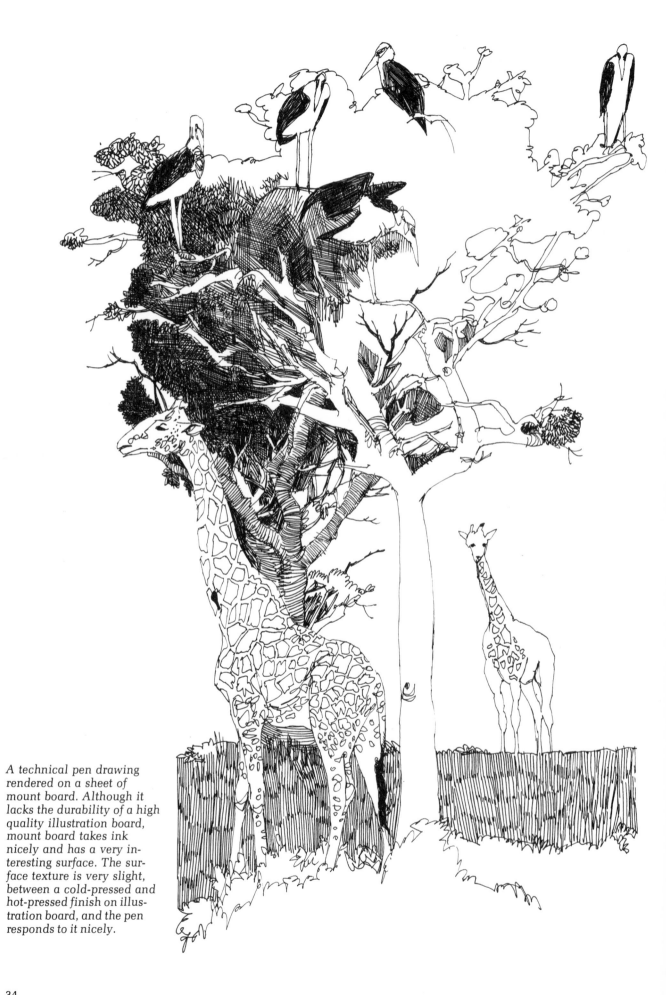

A technical pen drawing rendered on a sheet of mount board. Although it lacks the durability of a high quality illustration board, mount board takes ink nicely and has a very interesting surface. The surface texture is very slight, between a cold-pressed and hot-pressed finish on illustration board, and the pen responds to it nicely.

Chapter 3.

PEN LINE TECHNIQUES

To demonstrate a variety of pen techniques, I'll focus on two popular types of pens. Both of these pens are favorites of mine—the technical drawing pen and the crowquill pen. I like the technical drawing pen because it contains its own ink supply. This can be advantageous when sketching outdoors, eliminating the inconvenience of carrying around an ink bottle. In addition, the ink line is always uniform with the technical pen as the point consists of a small metal tube. This type of point allows you to draw lines in any direction on the drawing surface. Here I'll use the Pelikan Technos.

The crowquill pen is a versatile tool that offers a great range of line weights because of the flexibility of its point. The crowquill is a very handy tool, as it's used with a small, light holder. You can create an amazing variety of lines, textures, and tones with this pen point by applying varying degrees of pressure while drawing. Please note, though, that many of the techniques on the following pages can also be duplicated using the other pens discussed in Chapter 1.

At the end of the chapter are two demonstrations that illustrate the building up of tones by lines and by cross-hatching.

TECHNICAL PEN DRAWINGS

The technical pen is an excellent tool for doing drawings with even, uniform lines. In this example, which was an advertising assignment, the art director specified that the drawing be done in outline form, devoid of any tones or textures. When doing drawings of this type, you must not only consider what lines to put in but also what lines to leave out. While this type of drawing appears quite simple, it really requires a good deal of preliminary planning to be successful.

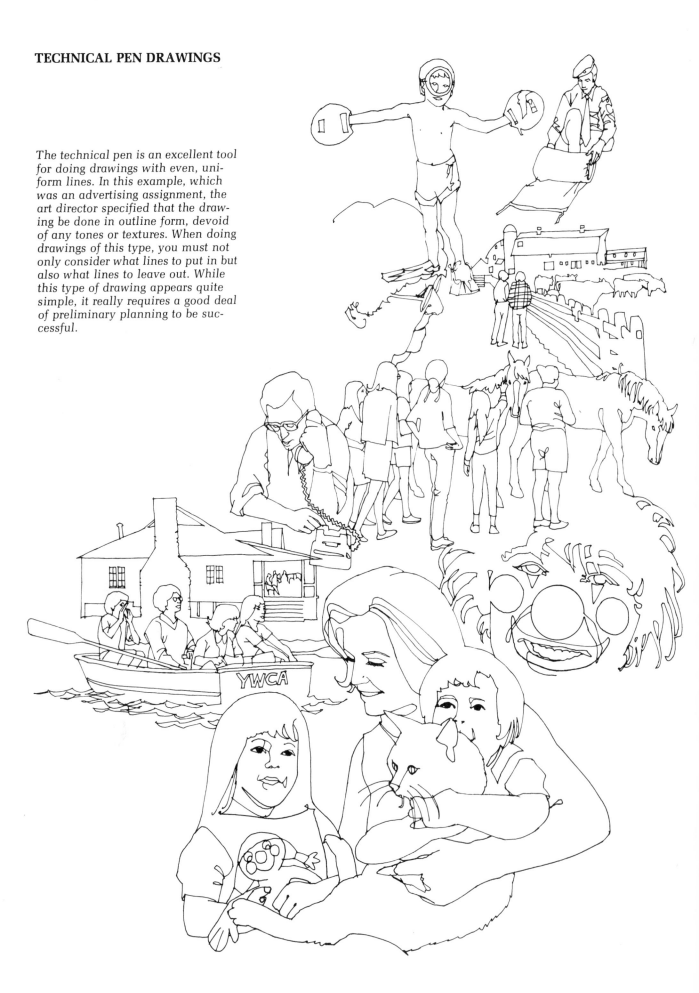

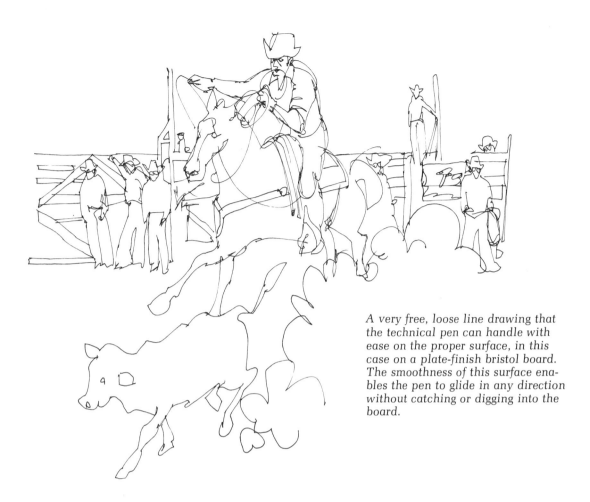

A very free, loose line drawing that the technical pen can handle with ease on the proper surface, in this case on a plate-finish bristol board. The smoothness of this surface enables the pen to glide in any direction without catching or digging into the board.

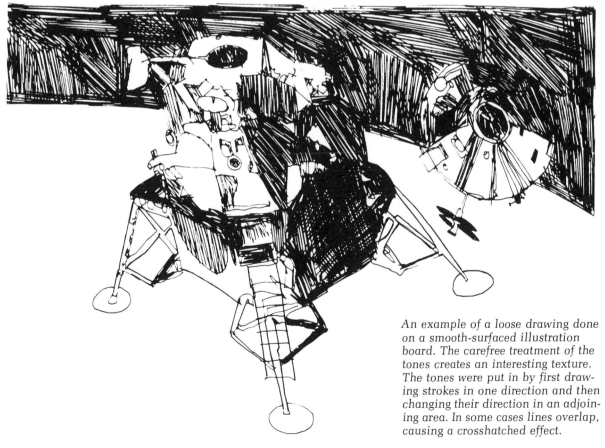

An example of a loose drawing done on a smooth-surfaced illustration board. The carefree treatment of the tones creates an interesting texture. The tones were put in by first drawing strokes in one direction and then changing their direction in an adjoining area. In some cases lines overlap, causing a crosshatched effect.

This is probably the most common use of the technical pen—a very tight line rendition of a mechanical object. The uniformity of its line weight makes the technical pen a perfect choice for drawings of a mechanical nature. A triangle and French curves were used to rule the lines in, and an ink compass was used for the wheels.

(Below) A loose sketch rendered on regular-surfaced, Strathmore illustration board. This board has a slight texture, an excellent surface for the technical pen. The surface is more pronounced than a plate-finish board or mount board, and thus it creates drawn lines that are sometimes slightly broken, giving the drawing a softer look.

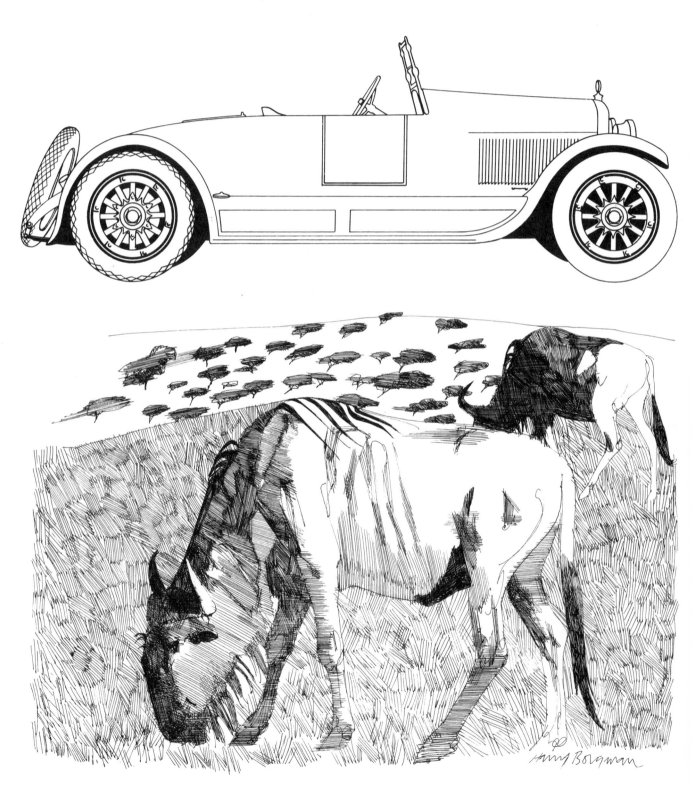

This view of the city of Nairobi, top, is drawn on Mylar placed over a composite photograph, bottom, of the city. Mylar is a transparent material with a matte surface that takes ink very well. Its hard, smooth surface enables you to sketch very freely without any possibility of the pen snagging the surface. Aside from tracing over photographs, sketches or diagrams, Mylar can be used for routine ink drawing and sketching.

Please note that as it was impossible to take a panoramic photograph of the city in one shot, I took several pictures from the same spot and matched them together later as shown.

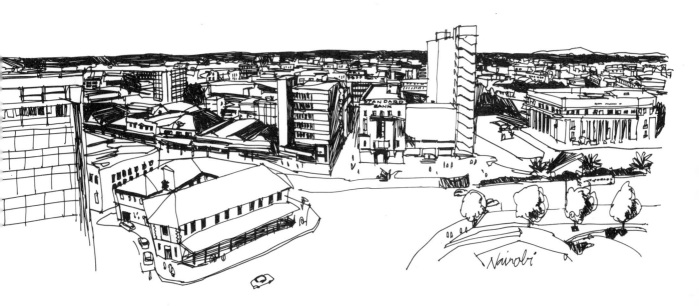

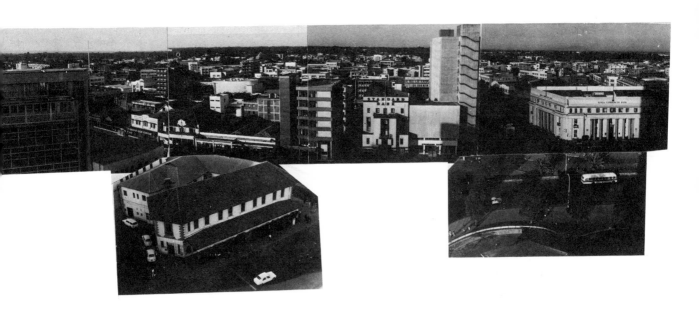

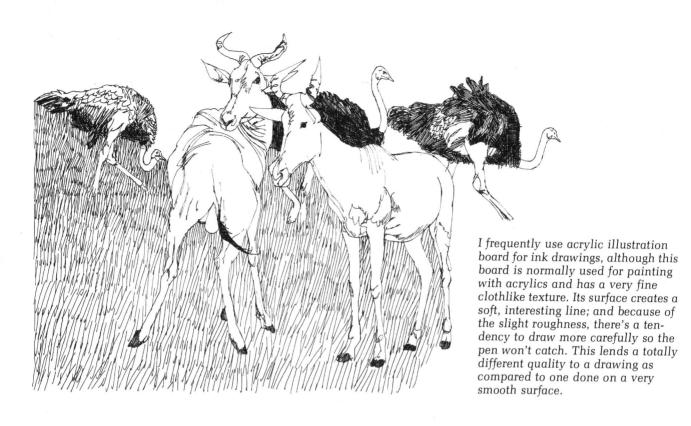

I frequently use acrylic illustration board for ink drawings, although this board is normally used for painting with acrylics and has a very fine clothlike texture. Its surface creates a soft, interesting line; and because of the slight roughness, there's a tendency to draw more carefully so the pen won't catch. This lends a totally different quality to a drawing as compared to one done on a very smooth surface.

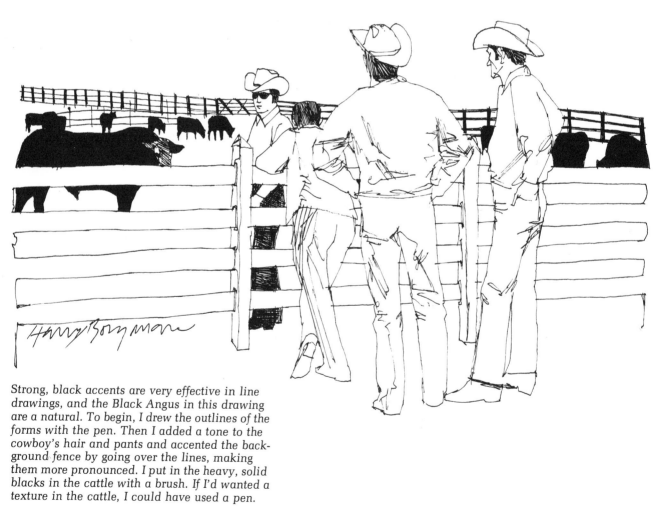

Strong, black accents are very effective in line drawings, and the Black Angus in this drawing are a natural. To begin, I drew the outlines of the forms with the pen. Then I added a tone to the cowboy's hair and pants and accented the background fence by going over the lines, making them more pronounced. I put in the heavy, solid blacks in the cattle with a brush. If I'd wanted a texture in the cattle, I could have used a pen.

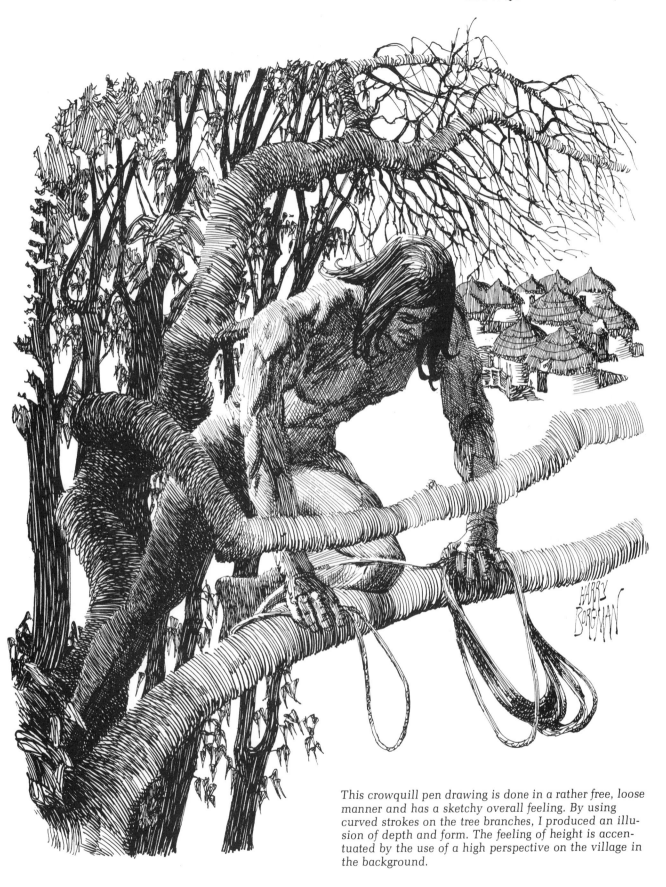

This crowquill pen drawing is done in a rather free, loose manner and has a sketchy overall feeling. By using curved strokes on the tree branches, I produced an illusion of depth and form. The feeling of height is accentuated by the use of a high perspective on the village in the background.

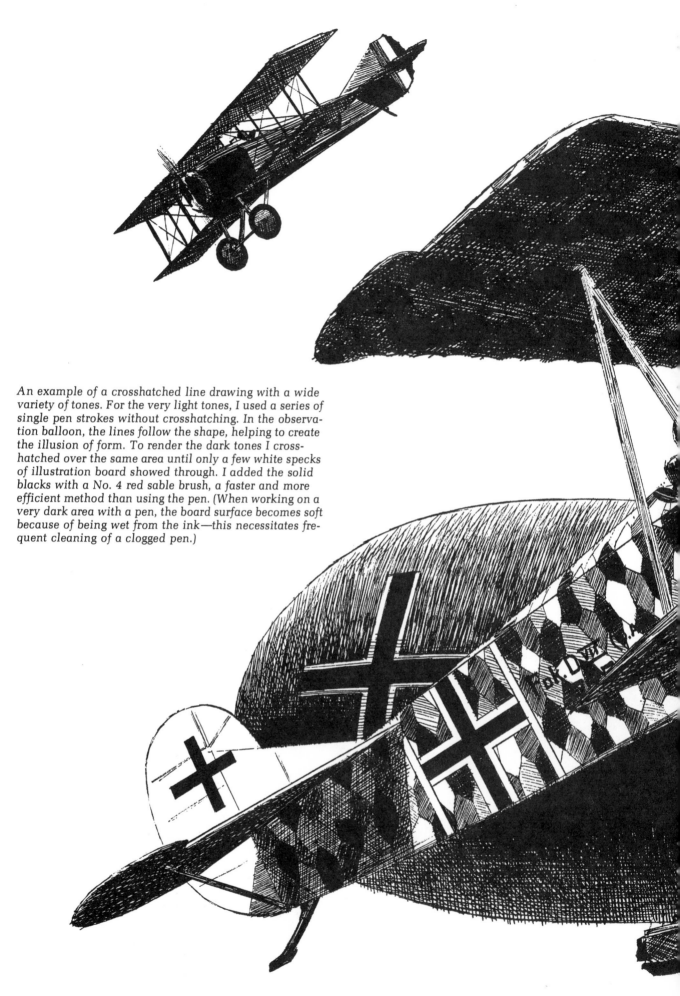

An example of a crosshatched line drawing with a wide
variety of tones. For the very light tones, I used a series of
single pen strokes without crosshatching. In the observa-
tion balloon, the lines follow the shape, helping to create
the illusion of form. To render the dark tones I cross-
hatched over the same area until only a few white specks
of illustration board showed through. I added the solid
blacks with a No. 4 red sable brush, a faster and more
efficient method than using the pen. (When working on a
very dark area with a pen, the board surface becomes soft
because of being wet from the ink—this necessitates fre-
quent cleaning of a clogged pen.)

Fokker D-VII

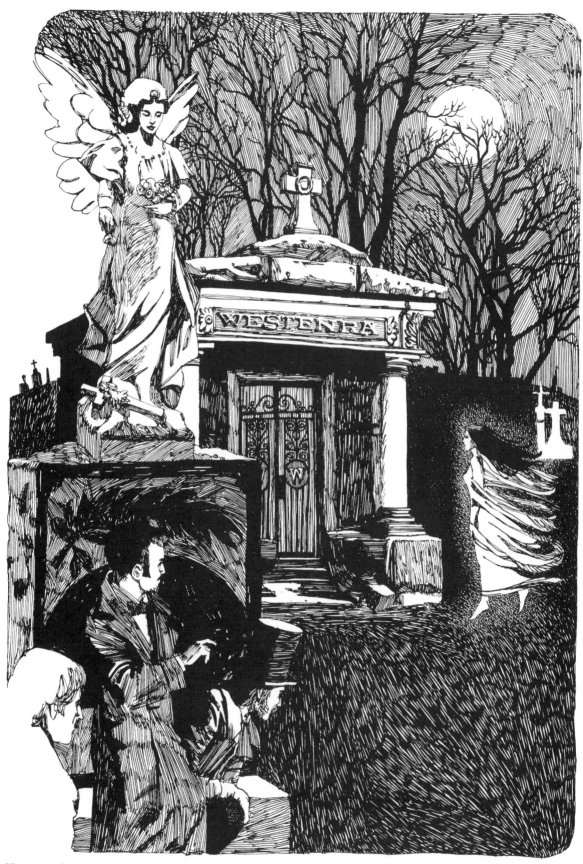

Here is a drawing that incorporates a variety of textures. Some of the pen strokes in the foreground are drawn very close together to build up a dark tone. Notice how the directions of some of the lines create a movement or flow through the drawing. I wanted to break up the outside shape of the illustration for interest, and therefore I decided not to fill in the tone behind the angel or finish the man in the lower foreground.

As this drawing is composed of several smaller ones, it's called a montage. It was done initially as an outline pen drawing to which the gray tones and solid blacks were added to clarify and separate the various elements. Again, the tones were carefully built up over the whole picture after the blacks were put in.

(Below) A mechanical object handled in a fairly loose manner. This drawing was done freehand with a loose crosshatched style. In this case, the pen was used with a very light pressure, causing the lines to be very fine and delicate.

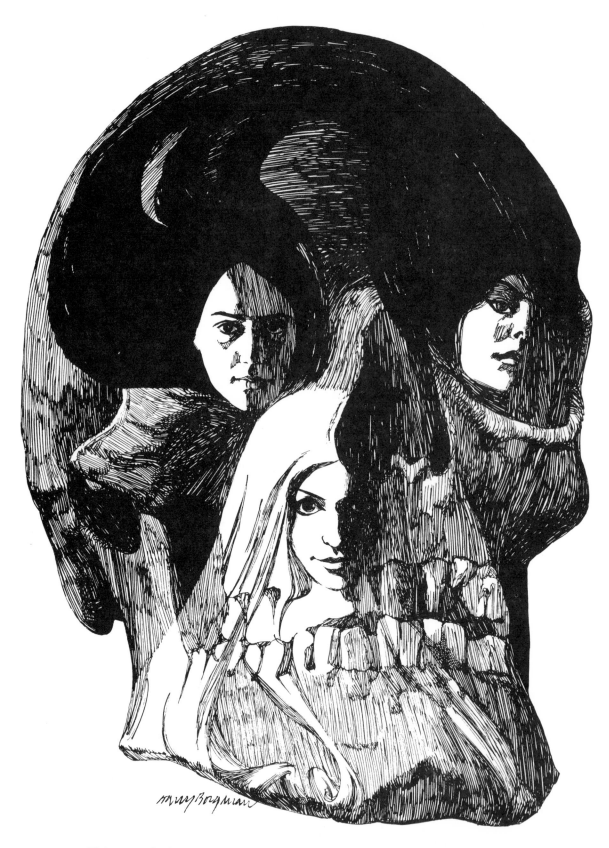

This example demonstrates the use of line as tone. The whole illustration is made up of lines drawn very close together to create a variety of dark gray tones. The use of pure whites and solid blacks adds to the drama of the drawing—notice how the ink strokes following the form in the skull add a great deal of dimension. Of course, this type of drawing is quite complex and must be carefully planned in preliminary sketches before inking.

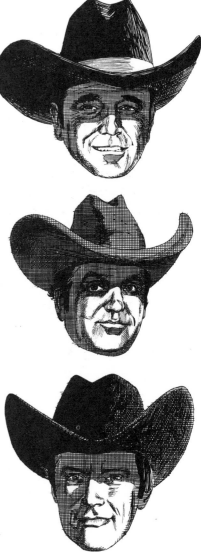

(Above) Here are some examples of portraits done in the crosshatched style. Most of the drawing is done freehand, with the exception of the shadow tones on the faces and of parts of the hats, both of which were done by ruling with the crowquill. I ruled the lines a little looser than usual to lessen their mechanical quality, although they're still fairly even in order to create the flat tone required.

This crosshatched drawing—more tonal than linear—was rendered in a finer, lighter technique than some of the other examples in this section. The ample amount of white helps the contrast of the picture. This drawing, and many others here, began as an outline to which the various tones were gradually added and built up until the illustration was finished.

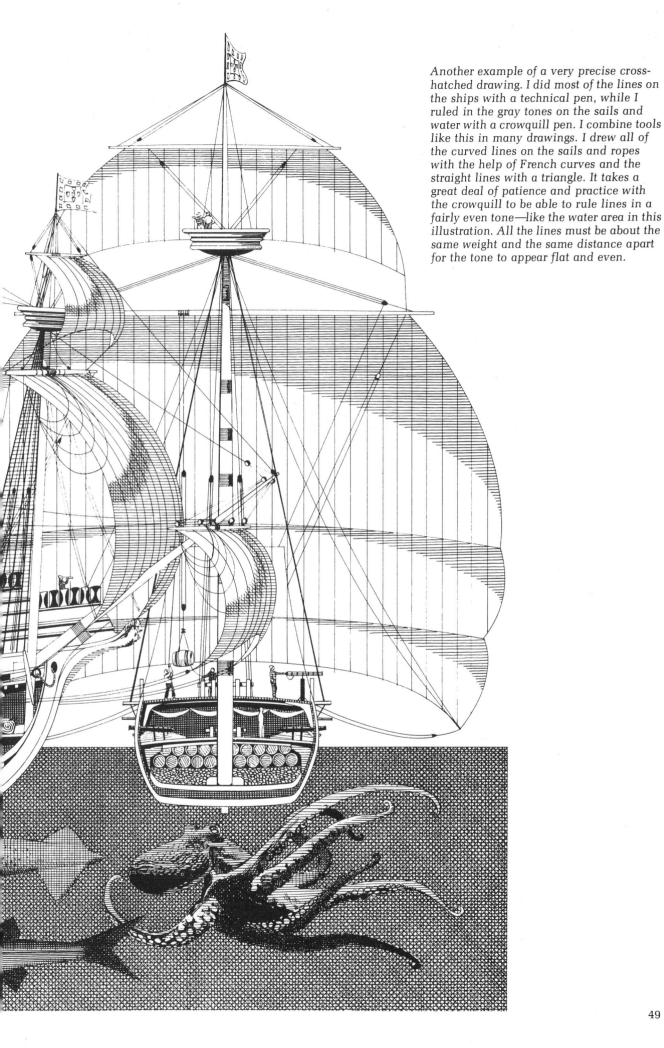

Another example of a very precise cross-hatched drawing. I did most of the lines on the ships with a technical pen, while I ruled in the gray tones on the sails and water with a crowquill pen. I combine tools like this in many drawings. I drew all of the curved lines on the sails and ropes with the help of French curves and the straight lines with a triangle. It takes a great deal of patience and practice with the crowquill to be able to rule lines in a fairly even tone—like the water area in this illustration. All the lines must be about the same weight and the same distance apart for the tone to appear flat and even.

Hail, Hail. The gang's all here.

No matter what your mowing needs are . . . you'll find one of Jacobsen's rugged giants will let you handle that big job of yours more easily.

Jacobsen G-10 Mowing Tractor
The G-10 will take all the work you can give it . . . and then some. And still finish first.
Designed especially for heavy-duty turf maintenance, the G-10 can effortlessly pull up to 11 gang mowers over rolling terrain.
What's more, its unusually low center of gravity—a scant 16 inches from the ground—provides excellent stability. Greater safety uphill. Downhill.
And talk about versatility. Think about this.
The Jacobsen G-10 can be used with any pull-type gangs: Fairway, Blitzer or Ram Lift Ranger.

Jacobsen F-10 Mowing Tractor
Get behind a Jacobsen F-10 and you'll be way ahead in getting the job done.
How? Simple. Because all the mowing units are ahead of the tractor wheels, you never leave any wheel tracks or streaks of uncut grass on fine turf.

Plus, for added safety, all the mowers are fully visible, at all times.
And, for convenience sake, individual controls let you adjust the width of the mowing swath between trees and obstacles.
But, most important of all, the F-10 goes a long way in helping you keep ahead; with a 7 gang unit you can mow approximately 60 acres per 8 hour day.

Jacobsen Fairway Gang
Available in 6 and 10 blade units, the Jacobsen Fairway Gang Mowers are ruggedly built to provide greater efficiency at lowest maintenance cost.

Jacobsen Ram Lift Ranger 3 & 5 Gang
Ready. Set. Mow. The Jacobsen Ram-Lift Ranger allows you to stay on schedule when traveling from job to job. Special hydraulic system raises units for travel. Lowers them at the job. The Ranger can be used with either the Blitzer or the Fairway Units.

Jacobsen Blitzer Gang
The Jacobsen Blitzer slashes maintenance costs because it is especially designed to cut rough areas at higher speeds. It also features a flexible frame hookup that eliminates skipping and scalping.

Jacobsen E-10 Mowing Tractor
The fastest tractor going. In more ways than one.
No brag. Just fact.
Jacobsen's "Fast One" has a top transport speed of up to 40 miles per hour. That means you spend less time on the road between jobs.
For extra convenience and safety, mowing units are controlled from the operator's seat. Wing lift operation enables you to raise and lower units without stopping. Plus, with the added option of hydraulic gang steering, you can back-up and maneuver at will.
Out front, the wide-wheel base keeps it stable and steady on side slopes.
The Jacobsen E-10: cuts the big turf down to size. Fast. Faster. Fastest.
For further information, call your local Jacobsen distributor. He'll be happy to answer any questions and arrange for a demonstration at your convenience.

JACOBSEN®
Jacobsen Manufacturing Company, Racine, Wisconsin 53403
A member Company of Allegheny Ludlum Industries

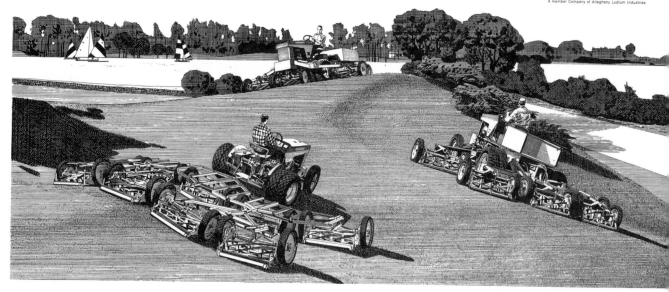

(Above) This advertising illustration for Jacobsen was a very complex and time-consuming project. It required a great deal of preliminary work, including composition sketches and pencil tone drawings before I could start the ink rendering. I began the ink drawing by first rendering the tractors and lawn mowers with the technical pen. Then I did the background with a crowquill, the large gray areas being rendered using the ruling method. This illustration is comprised of five distinct tone values: pure white, light gray, medium gray, dark gray, and solid black. I drew short pen strokes over the light gray ground tone to add some form and grass texture. I kept the values very simple, so the products wouldn't get lost in a maze of tones and textures.

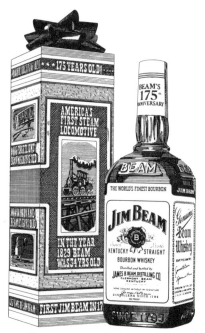

This very tight mechanical drawing was done using the ruling method discussed in Chapter 2 (see page 27). All the lines were very carefully ruled in, with the line weights and spaces in between kept fairly equal. The lightest value on the box consists of one set of lines without cross-hatching. The medium tone was created by drawing lines over the first set at a 90° angle. The darkest tone was achieved by adding two more sets of lines, both at 45° angles.

Give Jim Beam. A rare gift for over 175 Decembers.

Almost any type of pen texture can be used to create tones in ink drawings. The pen strokes used here are just lines drawn with quick, short strokes, sometimes overlapping to cause a slight texture. The solid blacks were put in with a brush, and then the ink tones were built up (made darker and darker) to their proper values.

Demonstration 1. Lines and Tones

The addition of tone to a drawing can add a great deal of dimension, texture, and mood. A good way to establish where the tones should go is by doing rough pencil sketches of your drawing on tracing paper. After working out the sketch to your satisfaction, you can use it as a guide when adding the tones to your ink drawing.

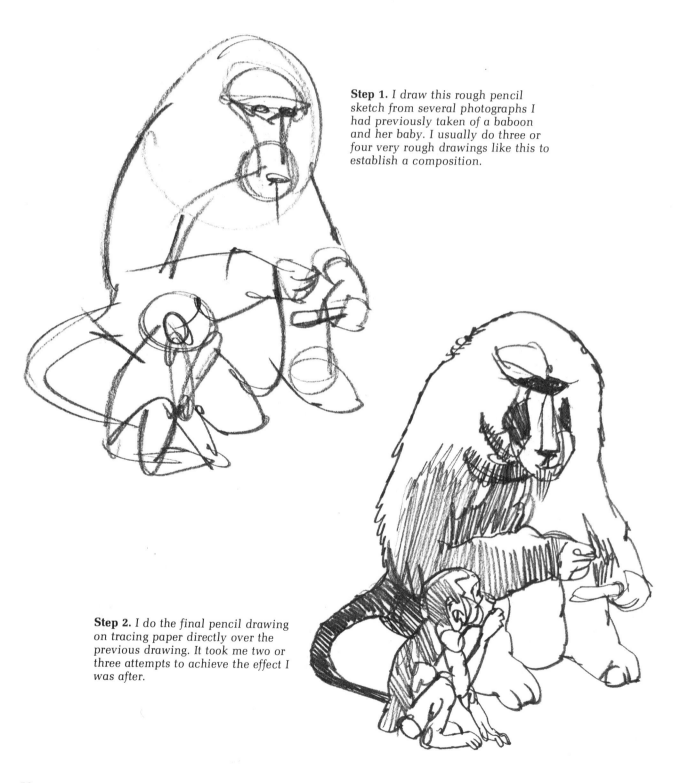

Step 1. *I draw this rough pencil sketch from several photographs I had previously taken of a baboon and her baby. I usually do three or four very rough drawings like this to establish a composition.*

Step 2. *I do the final pencil drawing on tracing paper directly over the previous drawing. It took me two or three attempts to achieve the effect I was after.*

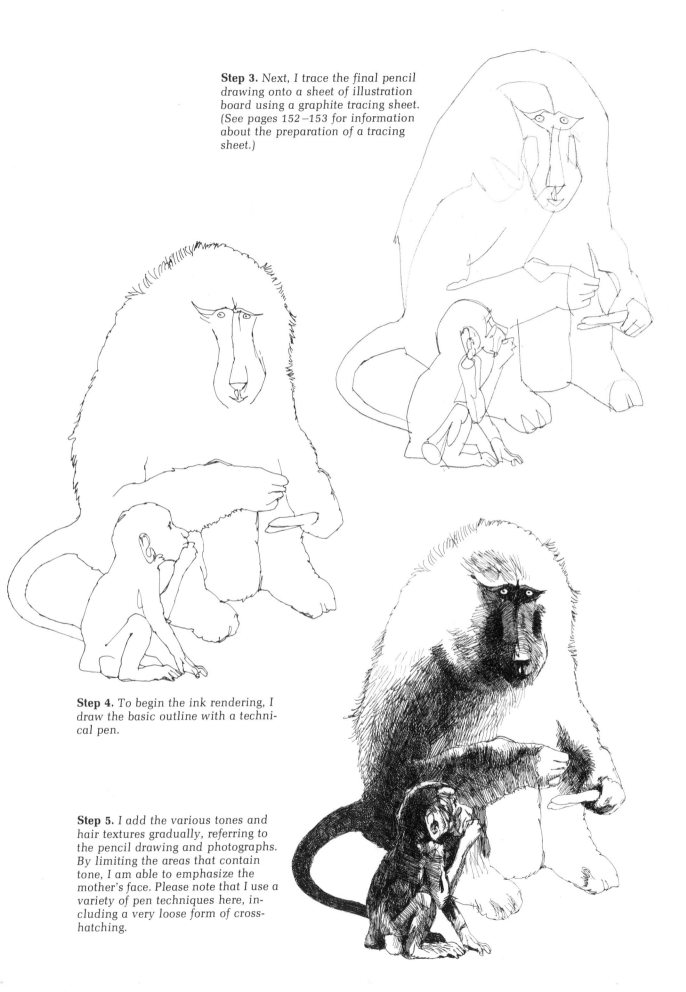

Step 3. *Next, I trace the final pencil drawing onto a sheet of illustration board using a graphite tracing sheet. (See pages 152–153 for information about the preparation of a tracing sheet.)*

Step 4. *To begin the ink rendering, I draw the basic outline with a technical pen.*

Step 5. *I add the various tones and hair textures gradually, referring to the pencil drawing and photographs. By limiting the areas that contain tone, I am able to emphasize the mother's face. Please note that I use a variety of pen techniques here, including a very loose form of cross-hatching.*

Demonstration 2. Crosshatching with a Pen

The technique of crosshatching to build up tones with pen lines is an excellent one for a variety of subject matter. This technique can be handled both in a very free manner and in a tight mechanical way. The crosshatched style, not being a very spontaneous method of drawing, generally requires more preliminary work than other techniques. You should do a tightly rendered pencil drawing with the proper tones and values before attempting the final ink version. Solving most of the problems at the pencil stage will make the final ink rendering a much easier task.

This style has great value in the commercial art field, and much of my own advertising work incorporates the crosshatching technique. Crosshatched drawings reproduce very well under the adverse conditions of high-speed newspaper printing.

It is advisable to thoroughly research any drawing you plan to do. You can find photographs of what you may need in magazines and books, or you can take your own. The reference photos for this demonstration were taken with a Nikon FTn camera, using Tri-X film. However, you don't need an expensive camera—a simple Kodak Pocket Instamatic will do nicely. Because of the short deadlines in the advertising world, I take many of my own reference photos with a Polaroid camera, so the results can be evaluated immediately.

Step 1. *This reference photograph was taken at a nearby Air Force base where this World War I Spad was undergoing restoration for its museum. A variety of views as well as a few close-up details were photographed. I pick a view from the contact prints and have an 8" x 10"/20.32 x 25.4cm blowup made from the negative. This particular negative produced a less-than-perfect print, as it is spotted, but reference pictures need not be perfect so long as you can see the details necessary to draw from.*

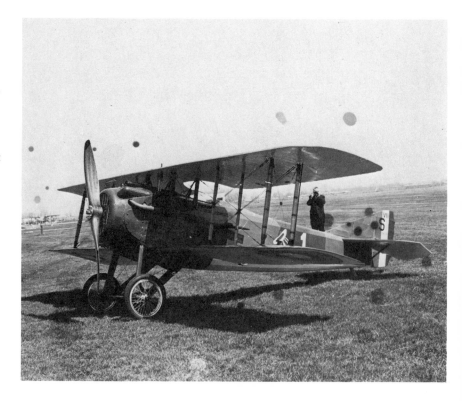

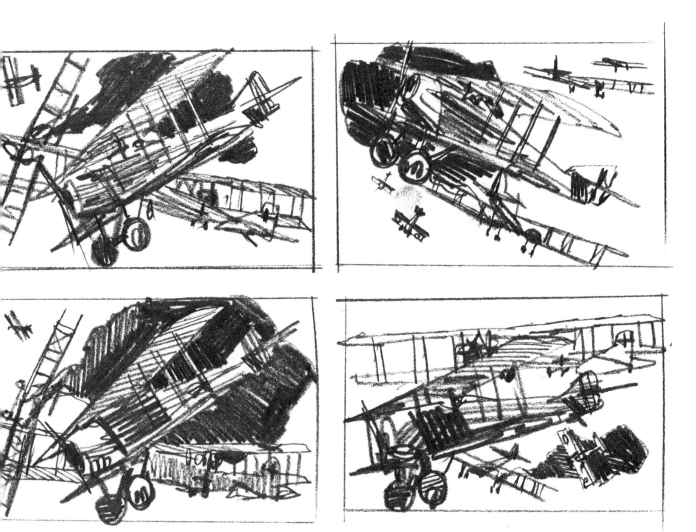

Step 2. *I do a few small rough pencil sketches to establish an interesting composition. I want to show the Spad engaged in an attack on a formation of German Gotha bombers. Having a rather extensive aircraft file, it is no problem to find pictures of the Gotha to refer to for the sketch.*

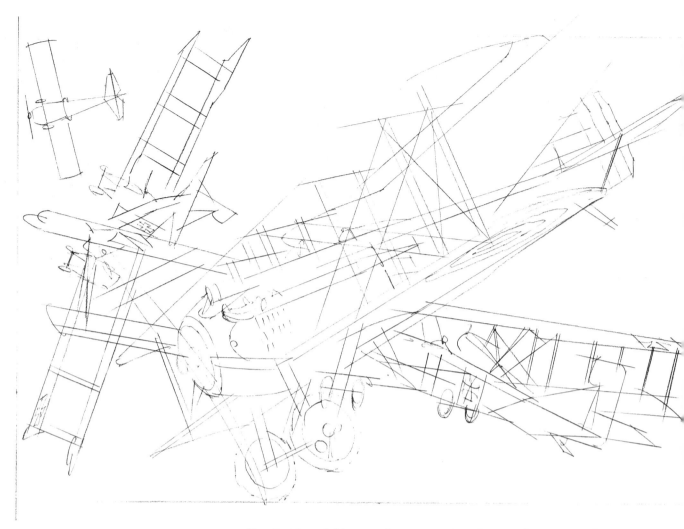

Step 3. *After picking out the composition that satisfies me, I make a pencil drawing on illustration board based on the sketch. I do this drawing directly on Strathmore illustration board by projecting the photo of the Spad with a Beseler projector. (See pages 154–155 for detailed information concerning the use of the projector.)*

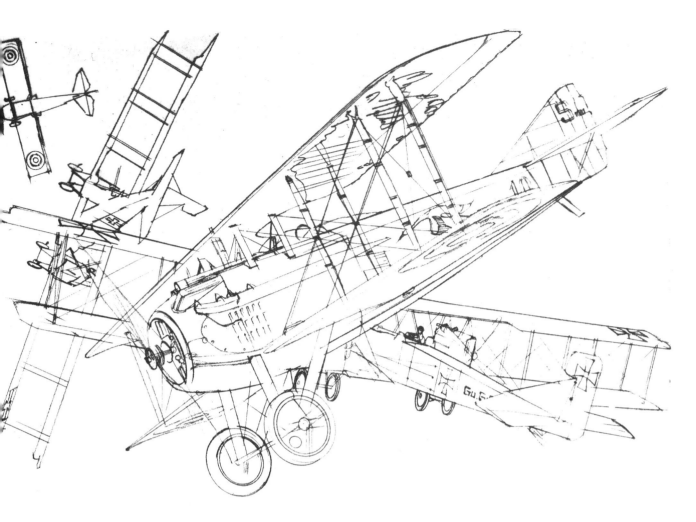

Step 4. *I tighten up the pencil drawing and draw in the details from the photo and other reference materials—I even add the squadron markings. So the small details can be added easily, I sharpen my pencil to a very long point. I keep the lead itself pointed by frequently using the sanding block. Left, I finish a detail.*

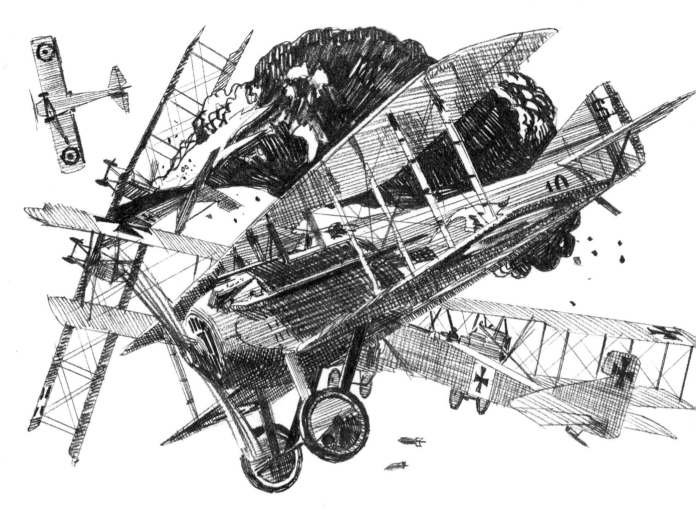

Step 5. *Now I must make another tight pencil drawing—in tones this time—to establish the various gray and black areas in the illustration. After I tape a sheet of tracing paper over the pencil drawing on the illustration board, I render the tone drawing with an HB pencil (left). This is a very important step, as I'll actually work from this sketch when I ink the illustration.*

In effect, I try to simulate the lines that will later be drawn in ink on the final rendering. Study this drawing carefully, and see how I've established the directions of the lines as well as the crosshatched patterns (above). I can easily remove any errors with a kneaded eraser and draw the areas back in correctly. When you reach this stage, solve as many problems as you can—this drawing is really the key to the final rendering.

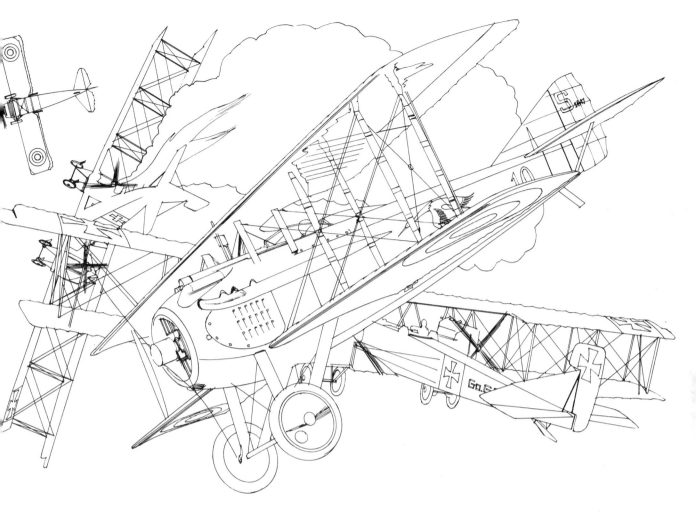

Step 6. This is the completed outline in ink, drawn directly over the pencil drawing from Step 4—it's ready for the addition of tones and black areas. You can see that I did the inking very carefully—the lines are all clean and even. In many places, such as the wheels and wings, I've established where the shadows and reflections will fall. All the careful planning and drawing at this and the previous stages will ensure the success of the final illustration.

Left, I'm using the technical pen with a ruler for some of the outline—I also use a triangle and French curves. Below left, I ink in the wheels with the help of an oval guide, a useful item for drawing mechanical objects. When you use all these tools, make sure that the previously inked lines are dry to prevent smearing.

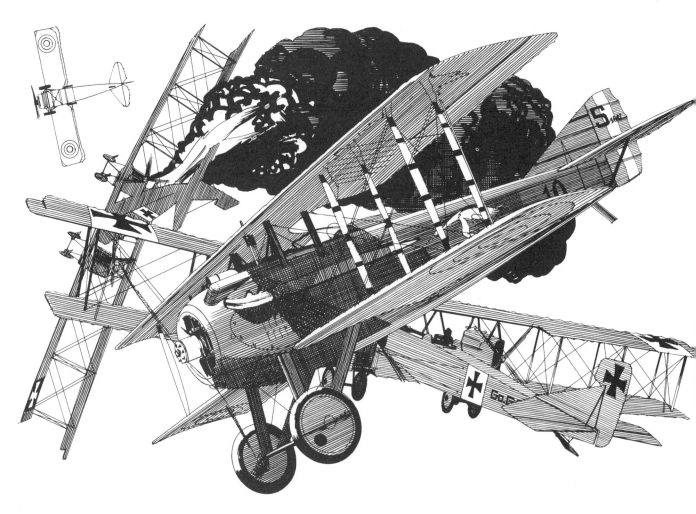

Step 7. *I start to add the tones, and at this stage the drawing is about half-completed. Notice how I'm building up the tones gradually all over the whole picture, rather than finishing one single object or section. This is very important—it will prevent me from overworking an area and rendering it too dark. I left the shadow area under the top wing unfinished to show how the tones are built up: first I added vertical lines over the horizontals, and then I drew lines at a 45° angle to build up the dark tone.*

In the small photograph on the left, I try to establish a medium gray area at the same time that I add the solid blacks to have something to work against. I start with the tones on the tail section, and then put in the black areas with a No. 3 red sable brush. I could put the blacks in with a pen, but it's much easier and faster to brush them in. In the center photo, I refer to my pencil tone drawing and to the other reference material. Right, I use the ruler to rest the crowquill on while I carefully draw in the lines to create the tones. This ruling technique with a pen may seem difficult, but with practice you'll gain the control that's required.

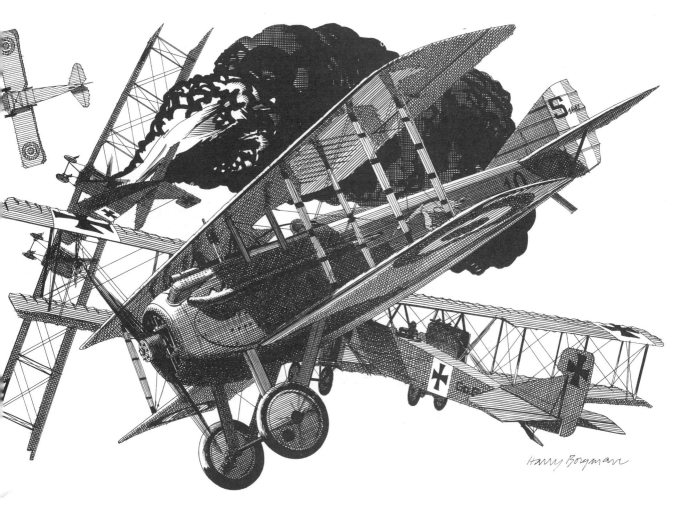

Harry Borgman

Step 8. The finished ink drawing. Refer back to the tone pencil sketch in Step 5, and compare it to the final rendering. Notice how well all the various tones are defined and separate nicely. Because of the proper spacing of the lines, the tones appear even and smooth. In a drawing of this type, there's always a danger of getting the lines to look too mechanical—a slight variation here and there actually helps to give a little life and interest.

Left, I continue the gradual tone buildup until the drawing matches the toned pencil sketch. The numerous details and smaller areas are finished with a crowquill pen. Below left, I check the drawing against reference material very carefully to see that squadron marking, wires, wing and tail ribs, and other details are added correctly.

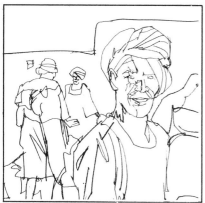
Basic pencil sketch.

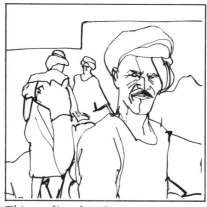
Thin outline drawing.

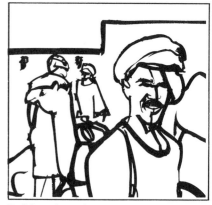
Bold outline drawing.

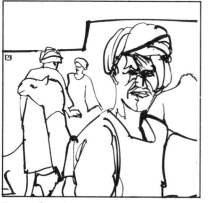
Loose drawing.

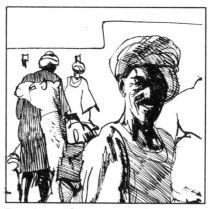
Drawing with textures and tones.

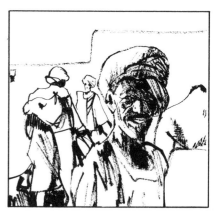
Drybrush drawing.

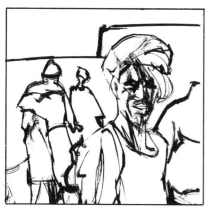
Bristle brush drawing.

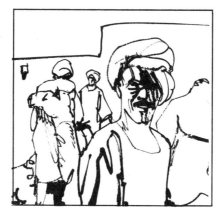
Drawing on blotter paper.

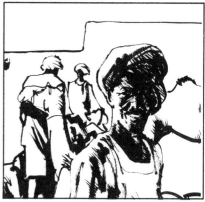
Drawing consisting mostly of shadows.

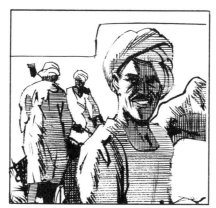
Crosshatched drawing.

BRUSH LINE TECHNIQUES

To show you some of the techniques that are possible with a brush, I've begun this chapter by showing you the same drawing in several different styles. The drawings are shown small here so you can compare them—each one is reproduced larger on the following pages so you can study them more carefully.

The brush is an excellent tool that gives you a great deal of control when you draw. Learning to use and control the brush properly requires a great deal of practice and discipline. I suggest you master the brush exercises in Chapter 2 before attempting any finished drawings.

This is the basic pencil sketch that I used for this set of drawings. Because this reproduction is made from a photostat of the original pencil drawing, the lines appear very black rather than gray. I often draw advertising illustrations with an HB pencil and then submit a photostat as the finished art. This technique reproduces very well and has a very different quality than a brush or pen drawing. Please note that drawings done with a charcoal pencil also reproduce very well without the need for a photostat, as the lines are quite black.

A thin outline drawing done with a Grumbacher series 197 No. 2 brush on a plate-finished bristol board. I produce the relatively even line by not varying the pressure on the brush while working. This type of drawing is done best with a No. 1 or 2 brush, as it's easier to maintain an even line with this small size.

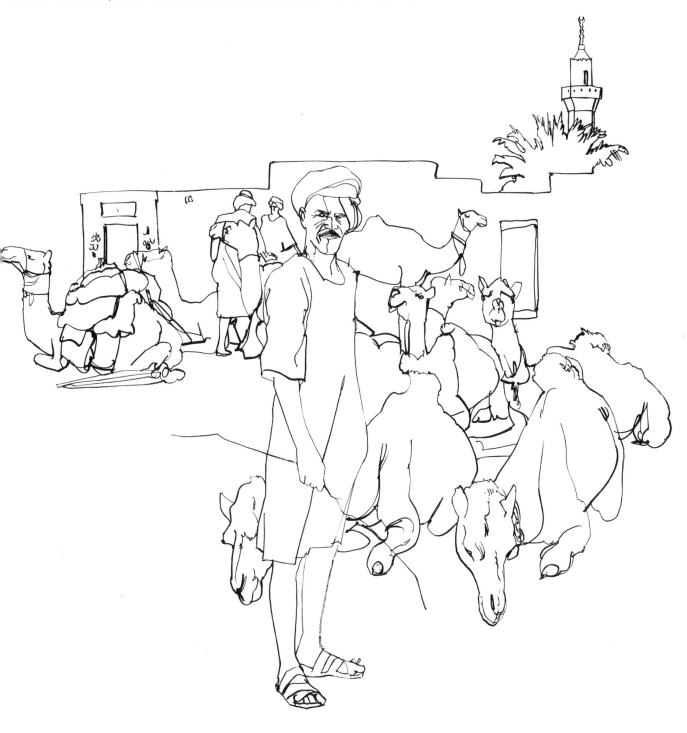

Drawing done with a much larger brush—Winsor & Newton No. 6 red sable—to achieve a very bold line on a smooth, plate-finished bristol board. When doing a drawing in this style, keep your brush fairly well loaded with ink so the brush has a rather fat point. It's difficult to draw small details in this style— you'll get a bold, almost calligraphic effect.

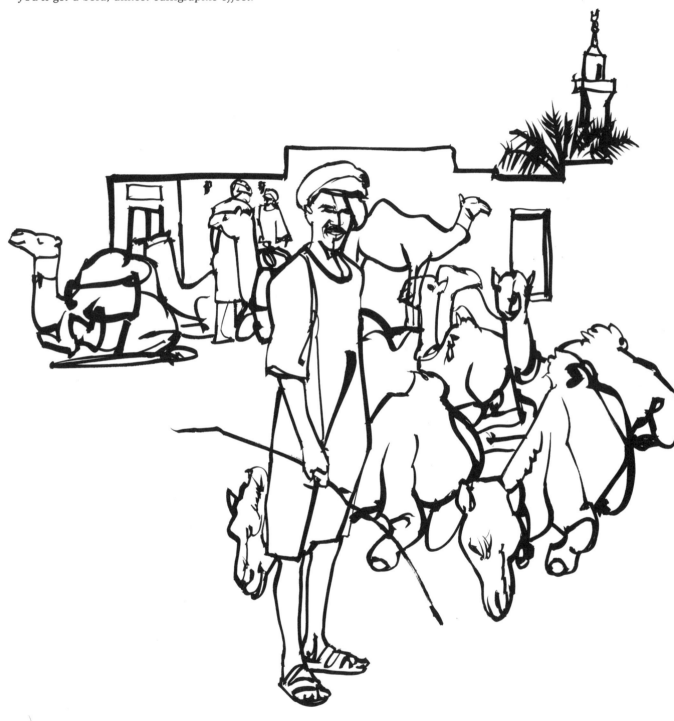

A very loose drawing done with a Grumbacher No. 2 brush on a plate-finished bristol board. The brush encounters very little resistance while drawing because of the slick surface—this allows a great freedom of line.

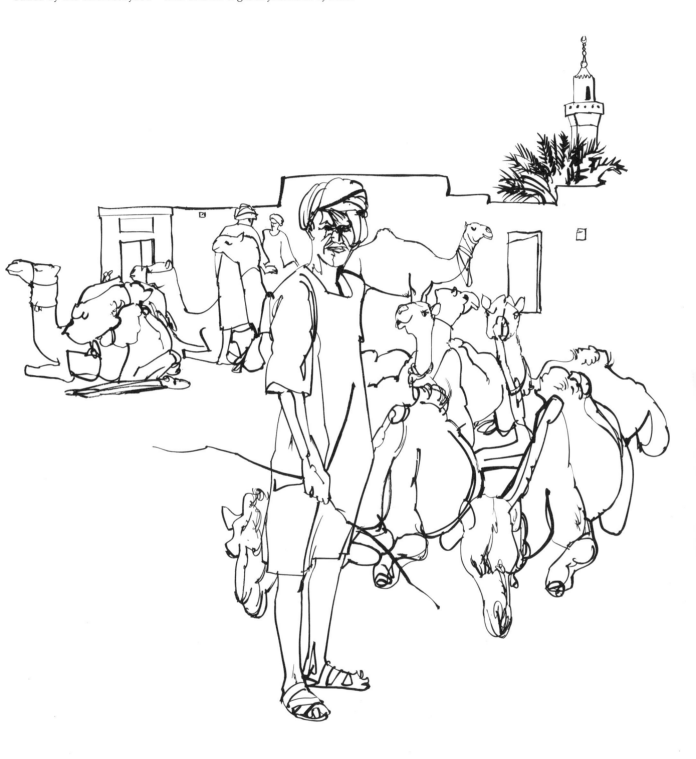

You can create a great variety of textures and tones using a brush, and many of them are impossible to duplicate with a pen. If you use the brush a little dry, only part of the surface texture picks up ink, creating a soft effect much like a pencil drawing. Notice the areas on the man's clothing and on the camels that are done in this manner. The drawing surface I use here is a Schoeller 2-ply, medium-surfaced bristol board and the brush is a No. 2 Grumbacher.

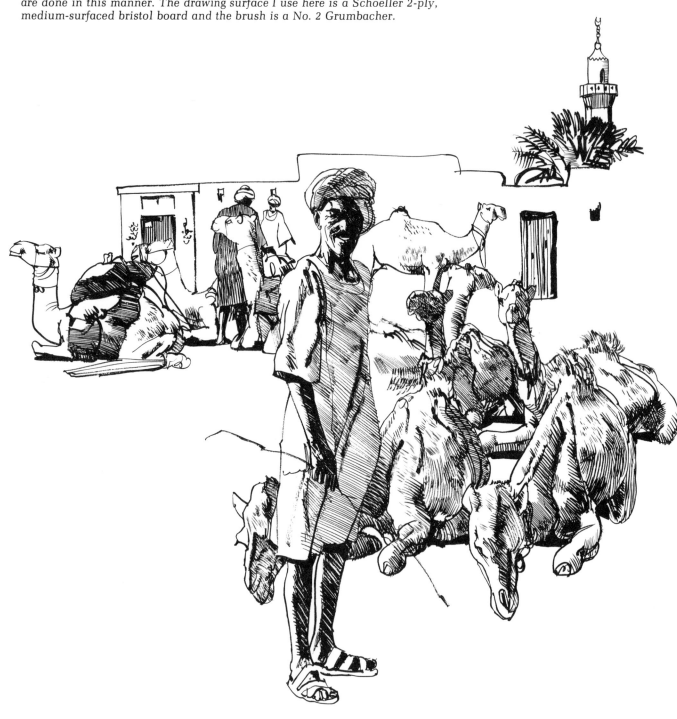

Drybrush drawings are unique because of their interesting textures and un-usual softness. Diverse effects can be created by drybrushing on differently textured illustration board surfaces. I did this drawing on Crescent No. 100 cold-pressed illustration board with a Winsor & Newton No. 2 red sable brush. I think that certain parts look like they were rendered with a charcoal stick or pencil. Remember that a drybrush drawing, being more complex than a regular line drawing, requires more preliminary planning—it helps to do a well-thought-out pencil sketch to use as a guide when drawing in ink.

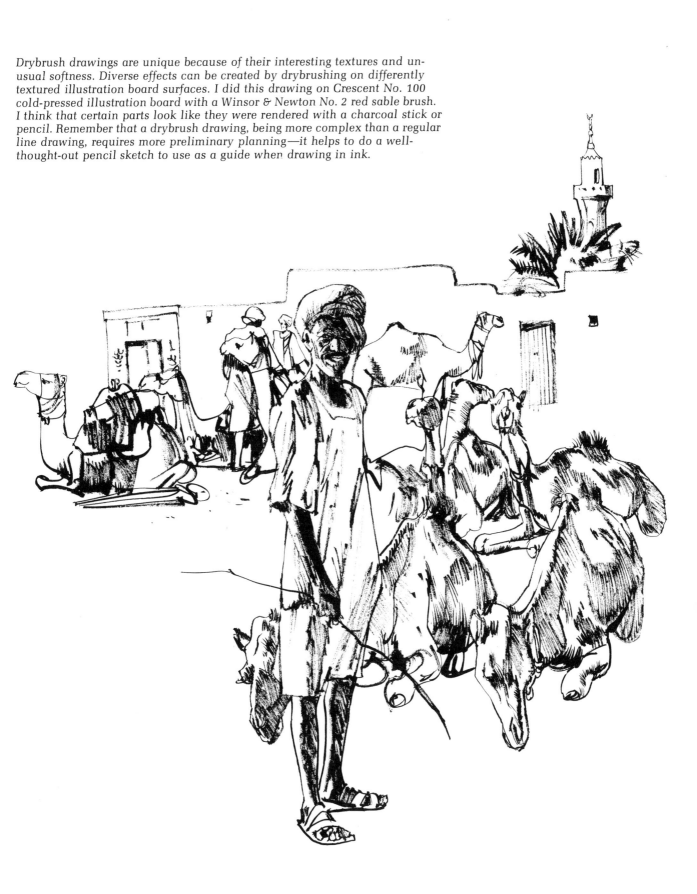

I did this drawing with a hog bristle brush—a Pelikan No. 607—on Schoeller 2-ply board. Although it's difficult to draw fine lines with a bristle brush, the general effect can be very interesting and unusual. For instance, you can "scrub" certain areas, such as the trees and parts of the camels here, for a drybrush effect. Bristle brushes are generally used for oil painting, and this drawing even looks very much like one I would do on canvas when starting a painting.

Blotter paper is a very suitable surface for drawing in ink with a brush—the surface has a nice resistance to it. Blotter paper, having an extremely soft surface, can't be overworked or corrected, and the result is drawings that are quite spontaneous. Some of the lines in this drawing are bold and heavily accented —to get them I really load the brush (a Grumbacher No. 2) and allow the blotter to soak up more ink in certain areas. The lighter lines are the result of using less ink in the brush. With a little practice, you'll learn to put these accents in the right places.

I produce an interesting effect by working primarily with the shadow areas, using as few lines as possible on Schoeller board with a Winsor & Newton No. 6 brush. This is an excellent brush with a very fine point—it enables you to draw very thin lines. Here the drybrush effect on the man's clothing lends a soft effect. And the small short strokes over the clothing's fold lines give an additional roundness. I did this drawing quite fast to capture a spontaneous sketchbook feeling.

This final example, done on Crescent No. 100 cold-pressed illustration board, is done in the crosshatched technique. Starting with a basic outline drawing and adding the tones, I draw many of the lines that make up the tones with a Winsor & Newton No. 3 brush and the ruling method. Some of the dark lines and black shadows are added last to help separate and clarify the elements in the picture.

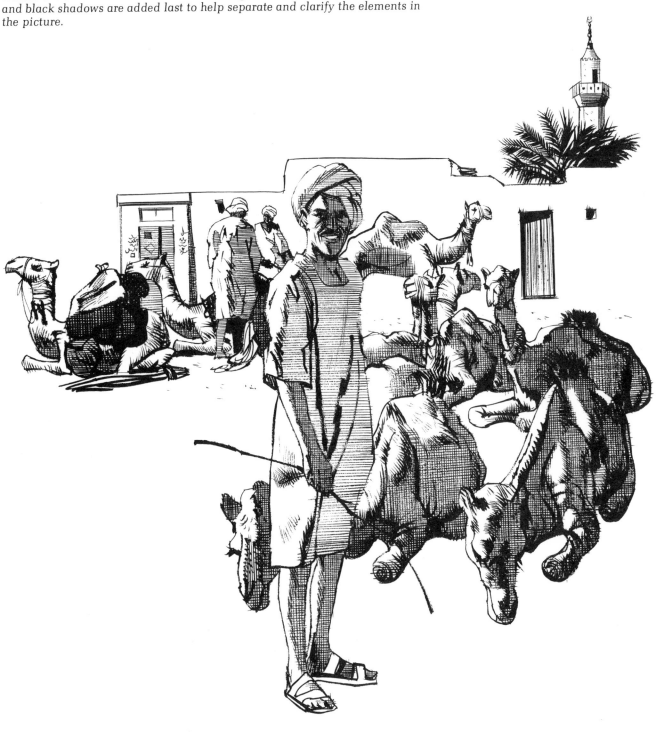

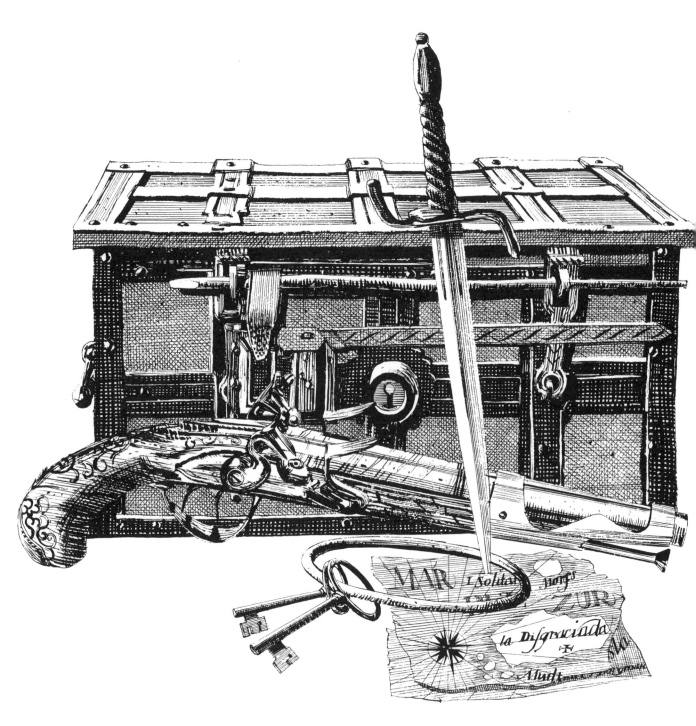

I did this crosshatched drawing entirely with a brush. Generally, I have more control using a brush, especially on a cold-pressed surface such as the one used here. On this kind of illustration board—with a little surface texture— there tends to be a slight pull or resistance when drawing with a brush. This tendency induces me to draw more carefully, and this helps me in the control of the brush. By the way, I drew many of the tones in this drawing with the brush in the ruling technique (see Chapter 2, Exercise Five).

Demonstration 3. Drawing with a Bristle Brush

Bristle brush drawings have an interesting quality that can't be duplicated with a soft sable brush. The nature of the bristle brush, very stiff and hard to point for fine lines, encourages a very direct, bold type of drawing—a sort of shorthand indication. It's difficult to render fine details with this brush, which forces you to think in an impressionistic manner. Drawing frequently in this bold, direct manner can be a great exercise that can help you develop your ability to see the important elements of a scene—a real advantage when sketching outdoors.

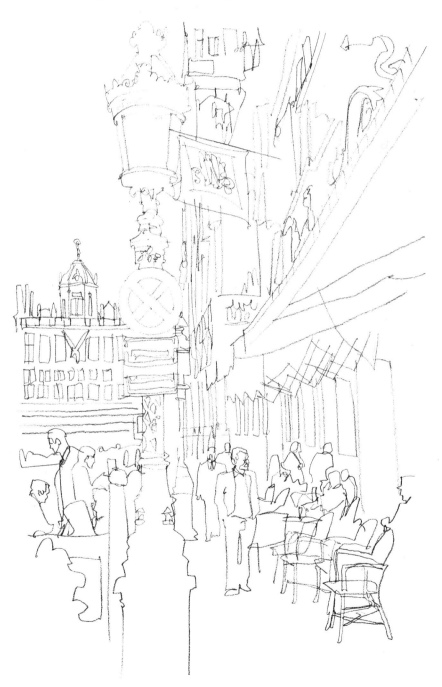

Step 1. *I do a rough pencil drawing first on Schoeller 2-ply bristol board, medium finish. This drawing is an accurate, although rather rough, diagram of the scene.*

Step 2. *Right, I begin the inking by outlining the dominant lamp post in the center of the composition. Far right, I add some blacks and draw in more details.*

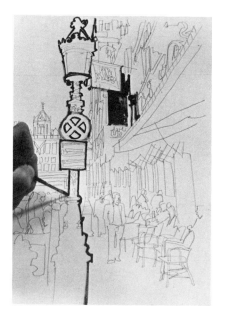 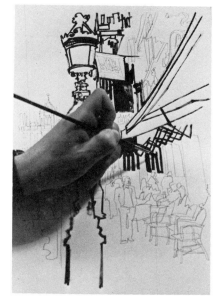

Step 3. *Right, I move on to the buildings at the left—I always try to work over the whole drawing rather than finish any one area. Far right, I turn the illustration to facilitate working. By using the brush on its narrow side, I can draw a fairly thin line.*

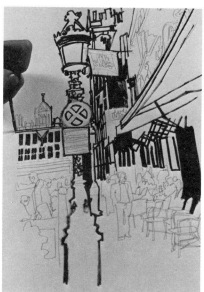 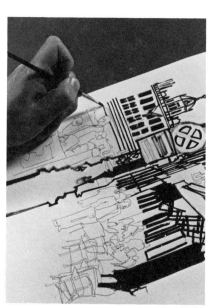

Step 4. *Right, I add the people and tables, drawing them very bold and simple in keeping with the rest of the picture. Far right, I put in the final black accents as the drawing nears completion. Large black areas can add a nice design quality as well as a lot of punch to a drawing of this type.*

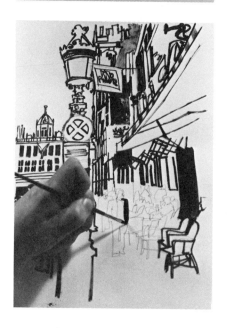 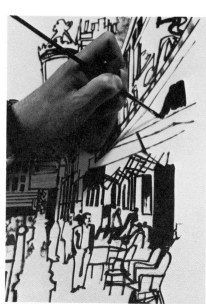

Step 5. *Although I made this finished drawing very carefully, it has a very sketchy, impressionistic quality. It's really impossible to put in much detail with a bristle brush, but I think leaving something to the viewer's imagination adds to the charm of the drawing. I look at a drawing like this as a design problem—and as an abstract composition of bold shapes and lines.*

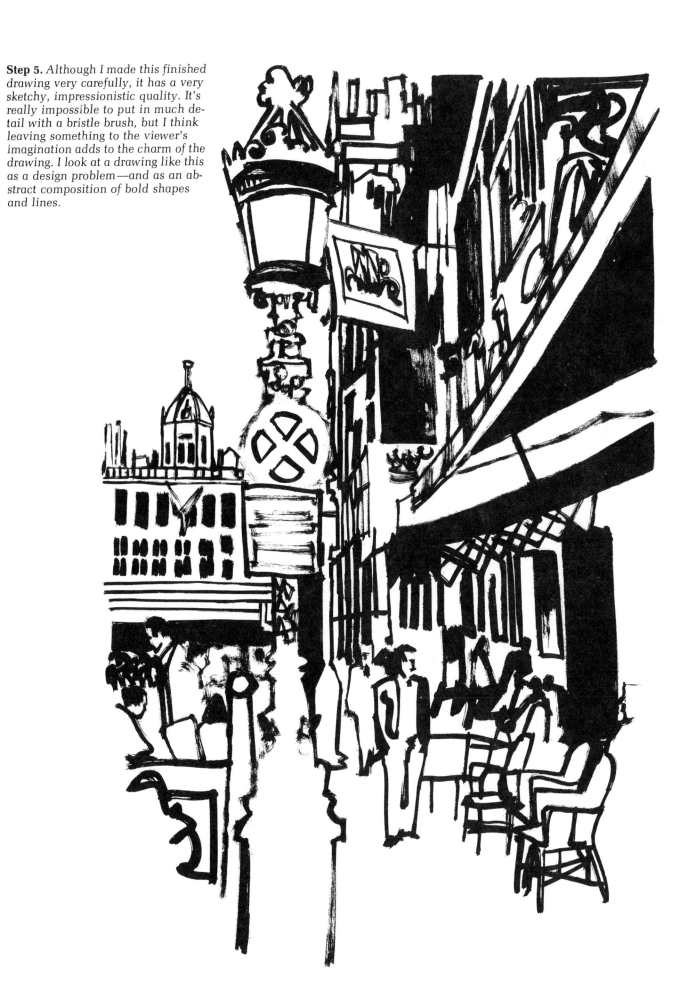

Demonstration 4. Crosshatching with a Brush

Crosshatching with a brush is really quite simple when you learn how to handle this tool. The brush is more versatile than a pen, and I personally feel that you can achieve more control using it. Learn to master the brush exercises in Chapter 2, and you'll be on your way to doing crosshatched brush drawings.

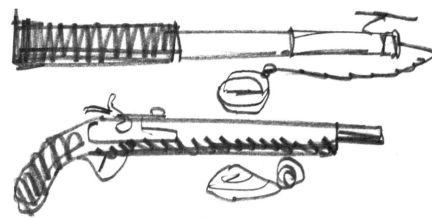

Step 1. First, I draw small pencil sketches to determine the composition. You could, of course, make hundreds of these sketches, but a few are all that's necessary. I generally do two or three and pick out the one that solves the particular problem best.

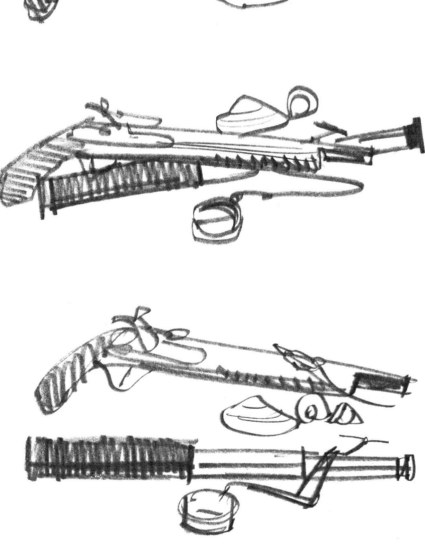

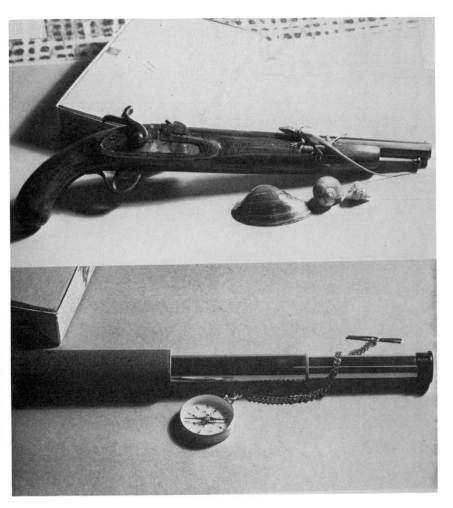

Step 2. *I took these reference pictures with a Nikon F 35mm camera. The gun is a new Spanish reproduction from a local gun shop, and the other items are just things I found around the house, including my son's pet chameleon. By gathering and shooting the best reference materials possible, I simplify many of the problems involved in doing a drawing of this type. Proper reference makes all the difference in the world to the outcome of the finished illustration.*

Step 3. *(Below) I project the photographs with a Beseler projector directly onto Schoeller medium-surfaced illustration board and make an accurate pencil drawing. Since my reference pictures were quite good, I was able to eliminate the next step, which would have been to make a tight pencil drawing to establish the gray tones in the picture. The fact that this illustration has no background also simplifies the rendering.*

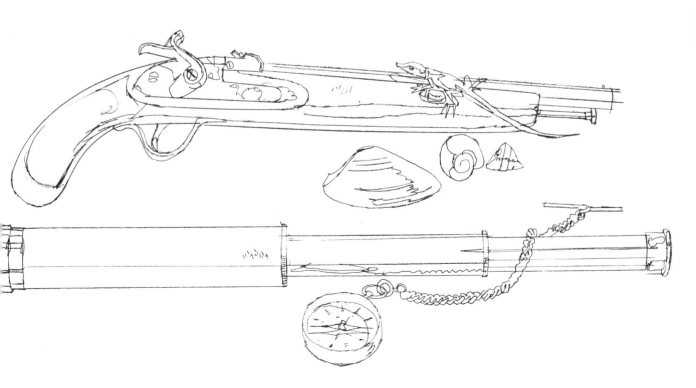

Step 4. *I start the inking as a basic outline drawing with a Winsor & Newton No. 1 red sable brush. Left, I rule in the straight and slightly curved lines with a brush. Center, I draw many of the smaller details freehand, using the reference photos as a guide. Right, to help me judge how dark the gray tones should be drawn, I add the black tones.*

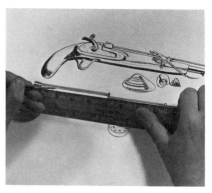 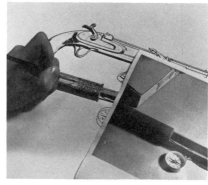

Step 5. *Left, I continue inking building up for a few of the gray tones by brush ruling. Right, I darken the leather on the telescope by crosshatching vertical lines over the horizontal ones. At the same time, I add the texture of the leather.*

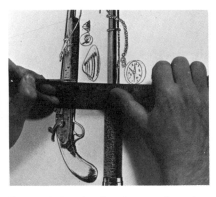 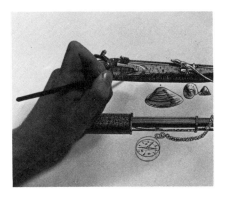 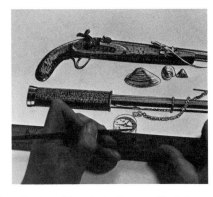

Step 6. *Left, I render the wood on the gun and add the shadow area by crosshatching. Center, I brush in the small nicks in the wood texture. Right, I finish off the last details and shadows.*

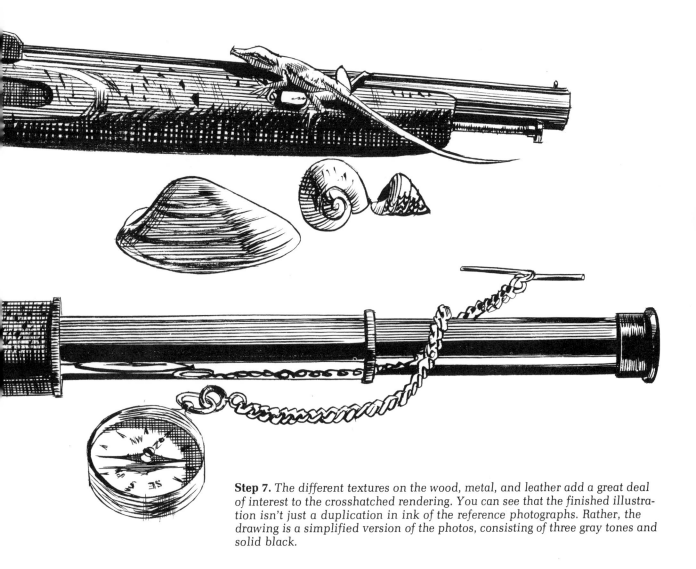

Step 7. *The different textures on the wood, metal, and leather add a great deal of interest to the crosshatched rendering. You can see that the finished illustration isn't just a duplication in ink of the reference photographs. Rather, the drawing is a simplified version of the photos, consisting of three gray tones and solid black.*

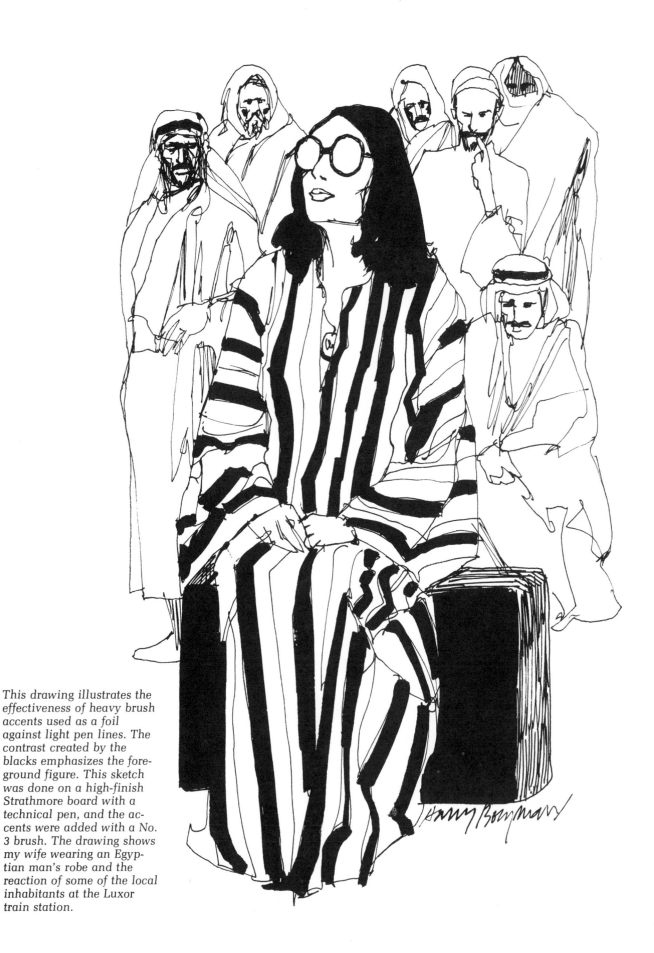

This drawing illustrates the effectiveness of heavy brush accents used as a foil against light pen lines. The contrast created by the blacks emphasizes the foreground figure. This sketch was done on a high-finish Strathmore board with a technical pen, and the accents were added with a No. 3 brush. The drawing shows my wife wearing an Egyptian man's robe and the reaction of some of the local inhabitants at the Luxor train station.

COMBINING PEN, BRUSH AND WASH TECHNIQUES

Utilizing different techniques in the same illustration can add a great deal of interest to a drawing. Each technique has a unique quality to add to a particular piece of art. Thin lines or a linear texture with a pen, very bold lines rendered wet or dry with a brush, and smooth flowing tones created with washes can be combined effectively. You should experiment with a variety of these techniques until you find the style that suits you best. I will cover many of the basic techniques in this chapter, but remember that the possibilities of combinations are endless.

I did this drawing and the next two for a travel brochure on Mexico. I wanted to create the feeling that I had worked on the drawings on location—it would have been nice to actually draw them on the spot, but this is not always practical. Tight deadlines and advertising budgets rarely include a trip for the artist. Luckily, I had plenty of reference pictures that I had taken while vacationing in Acapulco years before. I did all three illustrations with a technical pen, and I planned the black areas carefully before I rendered them with a brush.

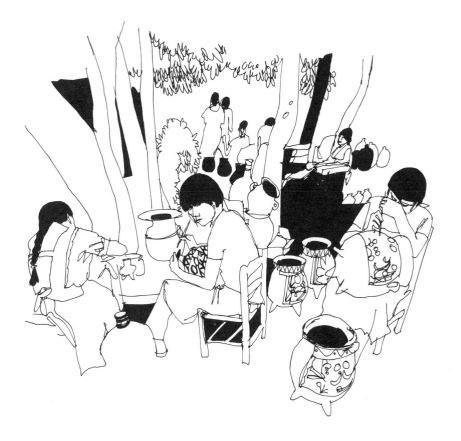

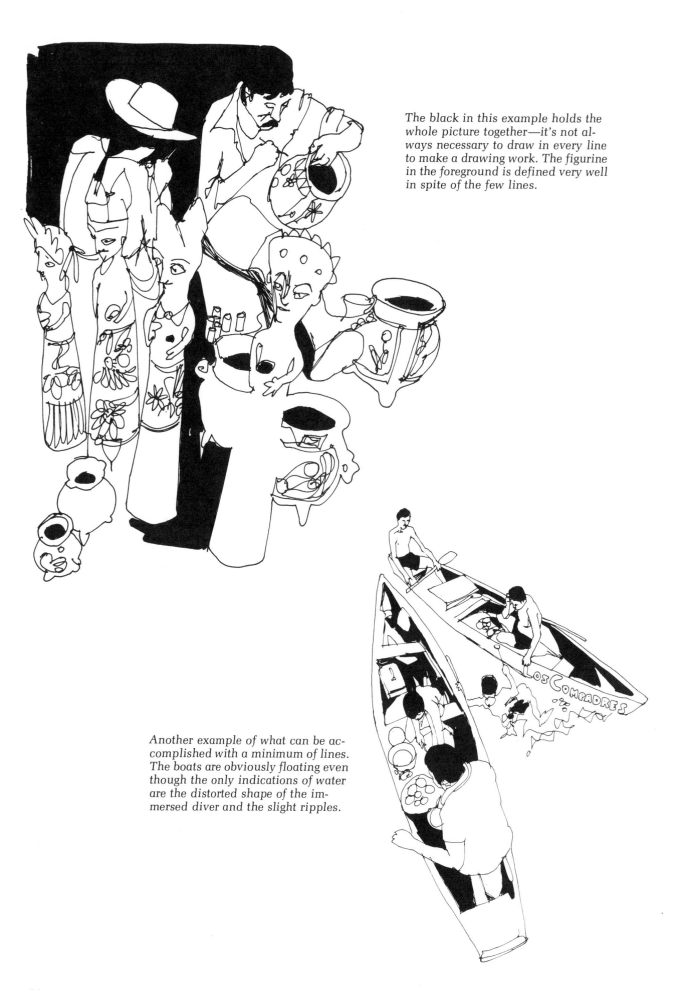

The black in this example holds the whole picture together—it's not always necessary to draw in every line to make a drawing work. The figurine in the foreground is defined very well in spite of the few lines.

Another example of what can be accomplished with a minimum of lines. The boats are obviously floating even though the only indications of water are the distorted shape of the immersed diver and the slight ripples.

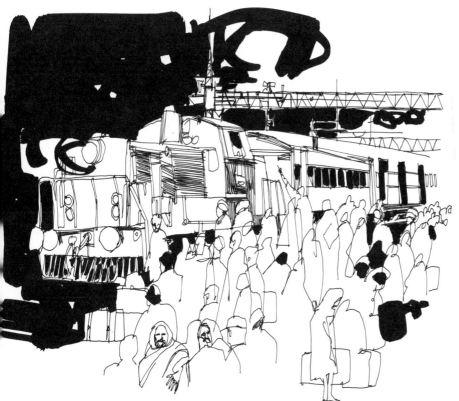

While vacationing in Egypt, my wife and I were caught in the October War of 1973. When we returned, the Detroit Free Press wanted to do a story on our experiences. Since I had not been allowed to take photographs during the war, the editors suggested I illustrate the story with sketches. I did these drawings from memory a few weeks after our return. This sketch is a scene at the train station in Luxor. The very sketchy, loose line and brushwork convey the feeling of an on-the-spot drawing effectively.

(Below) Going through customs at Soloum, Egypt. This scene was one of complete mayhem, with hundreds of trucks and cars piled high with boxes and luggage that the inspectors methodically searched. Notice that the slight amount of tone used in these Egyptian drawings really helps to establish planes and define the various objects. I tried to keep everything very simple, and I used the circular shapes in the upper right area to indicate spotlights.

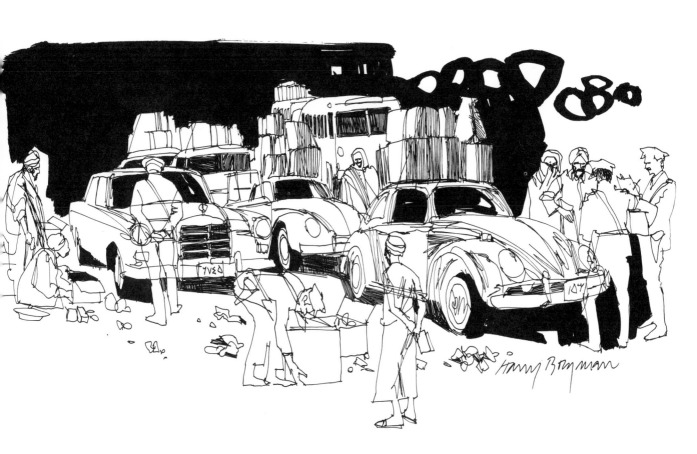

Another drawing from the Egyptian series. Our bus made a refueling stop around 3:00 A.M. at Derna, Libya, a very exotic place with moonlit date palms and mosques. It's surprising how much you can draw from memory even though the details may not be as accurate as you might like. The impressions of the scene can be very real.

(Below) I did this illustration for the Premier Corporation, and it depicts one of their ranches. I used a Crescent acrylic board, a technical pen, and a No. 3 brush used rather dry to take advantage of the board's unique surface texture. I rendered the cattle as a black mass without detail, but they're recognizable because of the correct shapes of the bodies and legs.

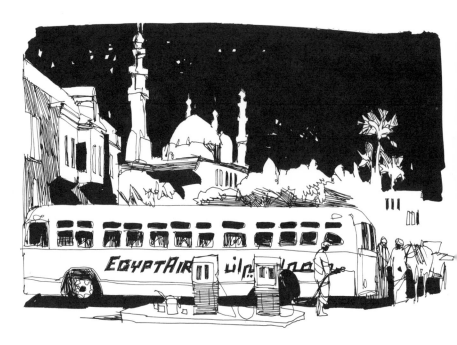

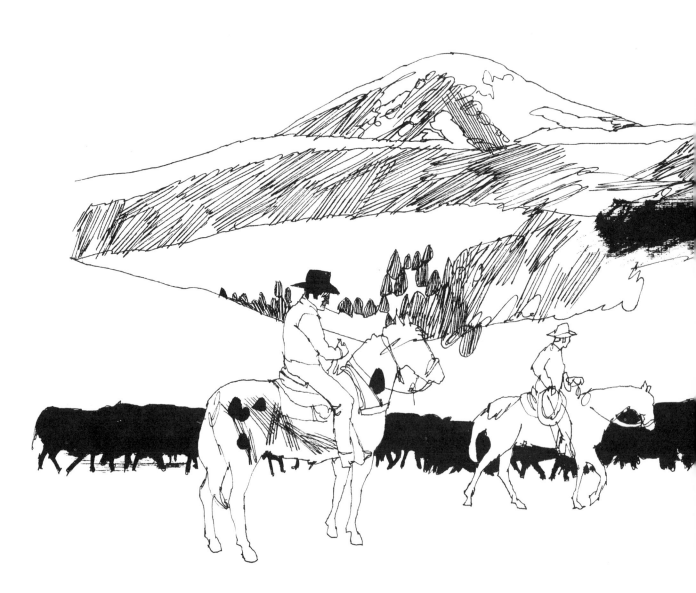

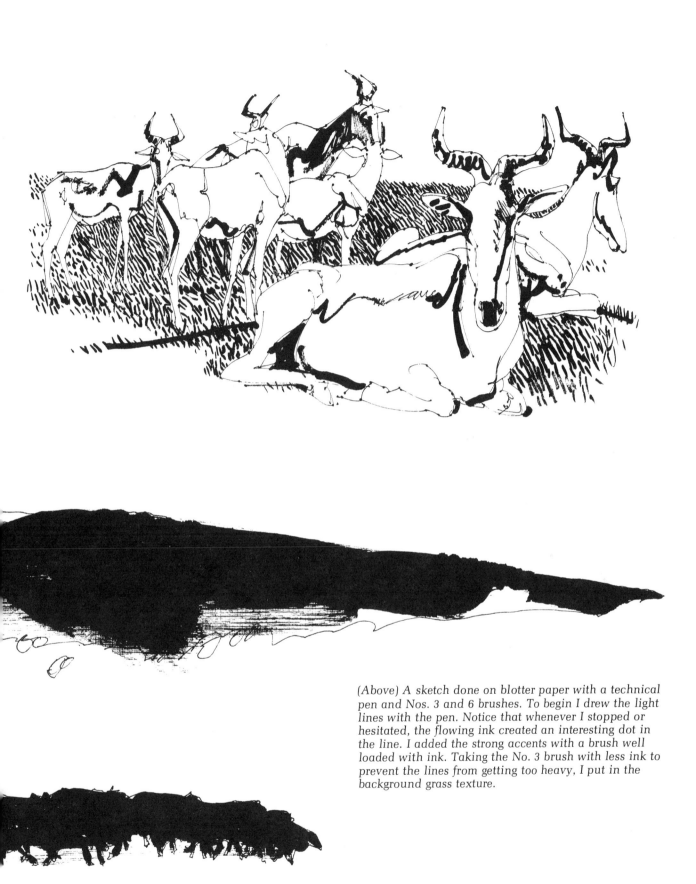

(Above) A sketch done on blotter paper with a technical pen and Nos. 3 and 6 brushes. To begin I drew the light lines with the pen. Notice that whenever I stopped or hesitated, the flowing ink created an interesting dot in the line. I added the strong accents with a brush well loaded with ink. Taking the No. 3 brush with less ink to prevent the lines from getting too heavy, I put in the background grass texture.

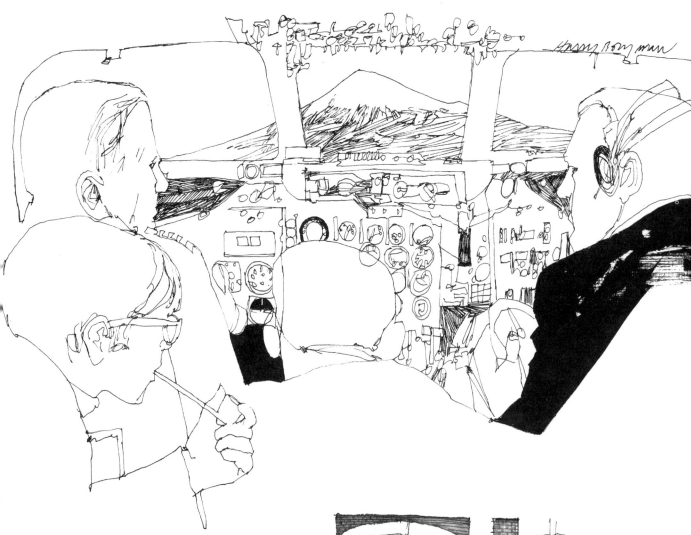

(Above) I had the good fortune of being sent to Japan on an exciting assignment for the Premier corporation. This sketch and the one of unloading crates on the next page were part of a series done to illustrate the shipping of cattle by air to Japan. I executed the drawings after I returned with a technical pen and brush on a linen-surfaced Crescent acrylic board using photographs taken during the trip for reference. Here we're approaching Mount Fujiyama.

I did this drawing with the Hunt 513 pen and water-soluble ink on Arches rough watercolor paper. The tones were produced by washing clear water over the pen lines, dissolving some of the ink—the lines don't dissolve completely and show through the wash nicely. This is a particularly good technique for quick outdoor sketching, when you may not want to carry along a mixing tray.

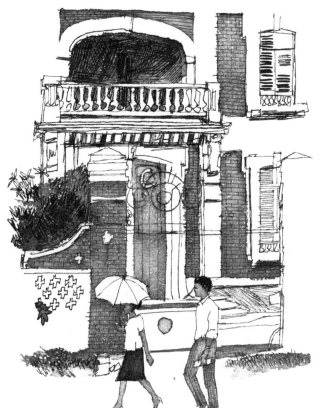

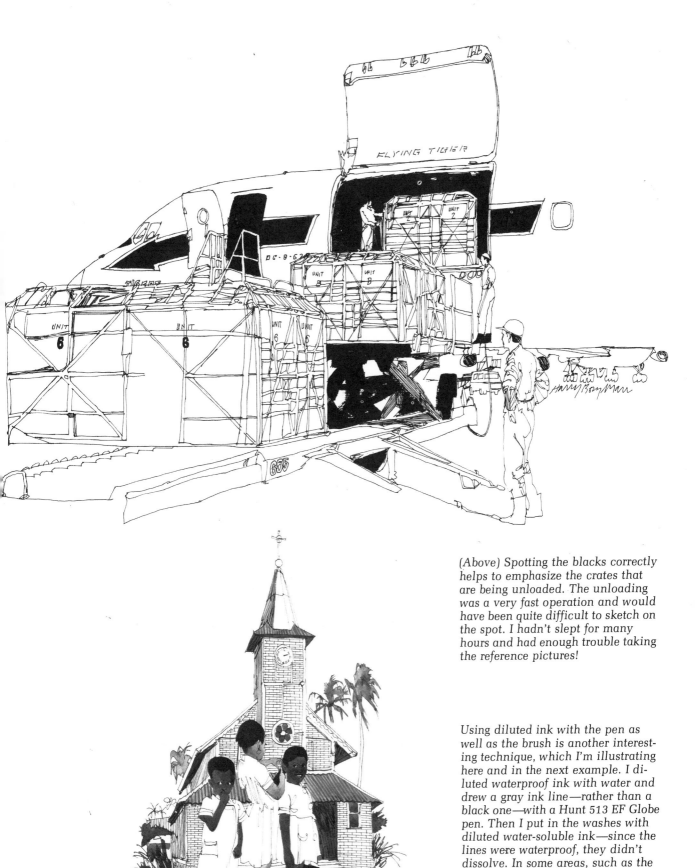

(Above) Spotting the blacks correctly helps to emphasize the crates that are being unloaded. The unloading was a very fast operation and would have been quite difficult to sketch on the spot. I hadn't slept for many hours and had enough trouble taking the reference pictures!

Using diluted ink with the pen as well as the brush is another interesting technique, which I'm illustrating here and in the next example. I diluted waterproof ink with water and drew a gray ink line—rather than a black one—with a Hunt 513 EF Globe pen. Then I put in the washes with diluted water-soluble ink—since the lines were waterproof, they didn't dissolve. In some areas, such as the church doorway and the schoolbag, I drew the pen lines in after the washes dried, which resulted in a darker line because of the transparency of the ink.

Demonstration 5. Pen Lines with Brush Accents

One of the most effective combinations of techniques is the use of bold brush accents with light pen lines. You can combine any number of pen types and brush sizes to do this. I drew the example in this demonstration with a technical pen and a No. 3 brush on a Crescent cold press illustration board.

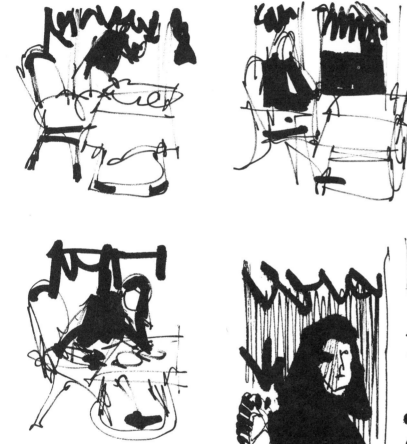

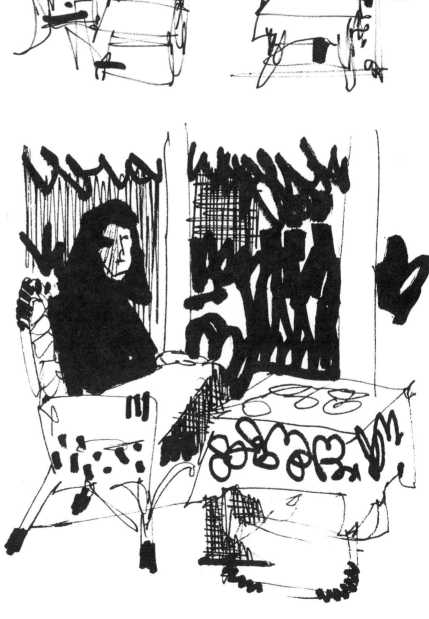

Step 1. *I start by doing four very rough composition sketches with a Pentel pen and a black Magic Marker. These are really diagrams to help me compose the scene and visualize the final result. Right, I establish what the final picture will look like in a larger, more detailed sketch drawn with the Pentel and marker.*

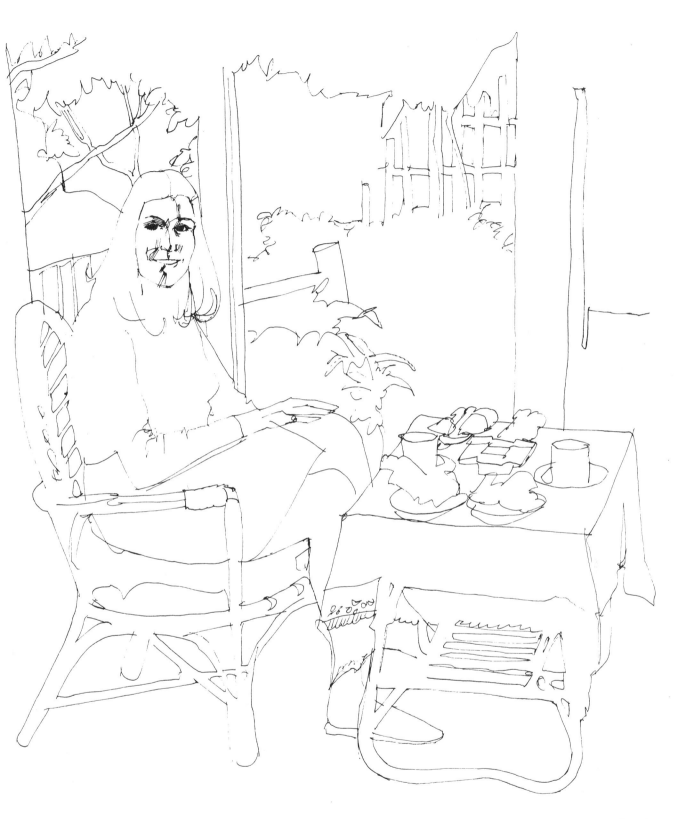

Step 2. Next, I trace a finished pencil drawing on the illustration board and render the outline form with a technical pen.

Step 3. *Right, I put in the bold accents in ink with a fairly well-loaded brush. The shapes and strokes help convey the impression of foliage. Far right, I add the hair and sweater loosely and give a pattern to the fabric on the chair.*

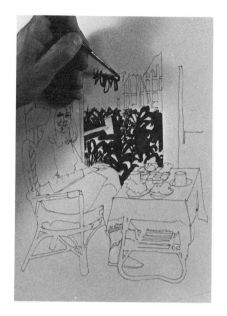 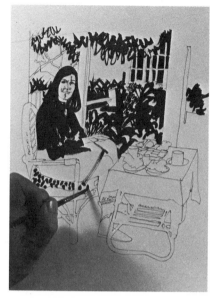

Step 4. *Right, I draw a very light tone on the shadow side of the face with the pen. Far right, I add tones to the background and the stockings. The drawing is starting to take shape and the elements separate nicely.*

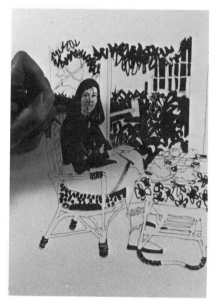 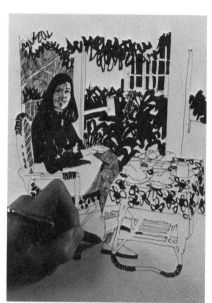

Step 5. *Right, turning the board for convenience, I crosshatch another set of lines over the stockings to darken the value of the tones. Far right, a light gray shadow tone in the cups and saucers finishes off the table area and a final darkening of the background by crosshatching completes the drawing.*

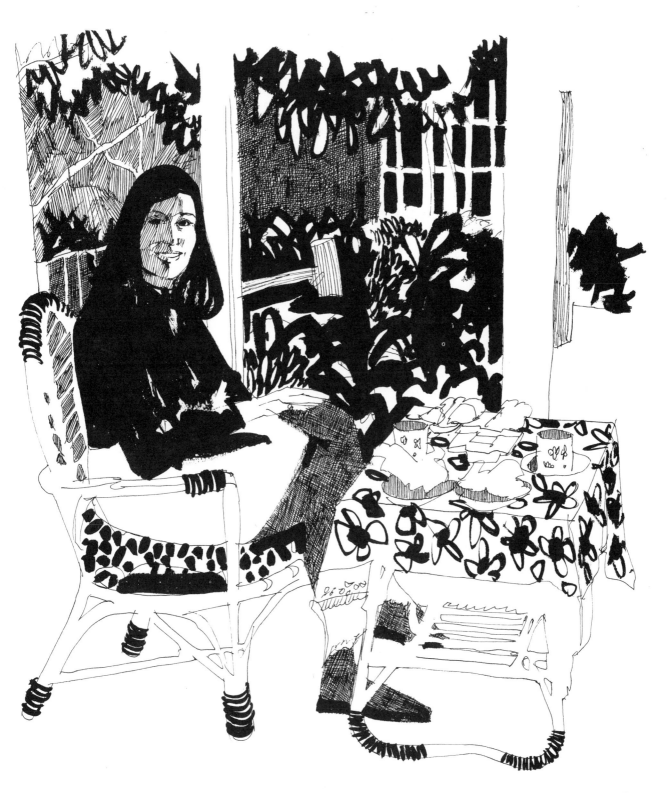

Step 6. *The overall feeling of this finished drawing is quite free—even the crosshatching is rendered in a loose manner. In spite of the casual style, though, the drawing is very accurate—the important features such as the nose, eyes, and mouth are in the right places. If part of this drawing, such as the crosshatching, had been handled too stiffly or mechanically, it would have looked very much out of place.*

Demonstration 6. Pen and Brush Drawing with Ink Wash

Combining pen, brush, and a wash tone of grays is an effective technique. Usually, I draw the line first and then establish the gray values with wash tones. This technique can be used on a great variety of illustration board surfaces as well as on watercolor papers.

Experiment with several kinds of illustration boards until you find the surface you feel most comfortable working with. I do the basic line drawing with waterproof ink that won't dissolve when you brush over it with a wash of either diluted water-soluble ink or diluted lampblack watercolor. It's difficult to achieve a smooth tone washing with waterproof ink, so stick to the water-soluble variety. Please note that a hair dryer is a useful tool to dry washes quickly. For mixing the washes, I use either a small ceramic tray with several wells or a large porcelain tray. Even a large ceramic plate will work.

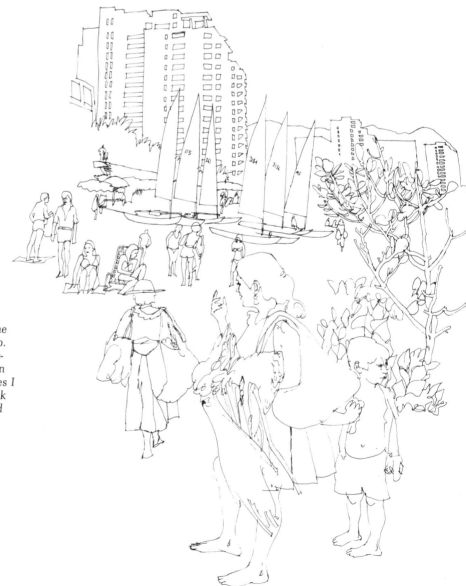

Step 1. *I draw a complete outline (that's ready for the addition of the gray wash tones) on a Crescent No. 100 board with a cold-pressed surface. I do this with a technical pen and waterproof ink. For the washes I will use Higgins nonwaterproof ink with a No. 6 Winsor & Newton red sable brush.*

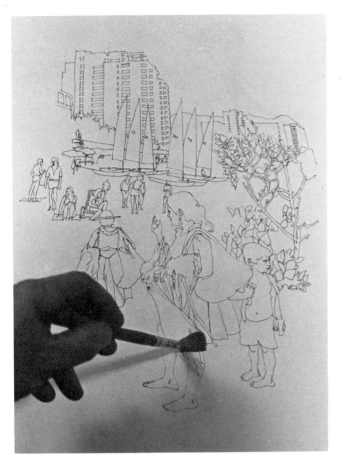

Step 2. *(Above left)* Using a large No. 6 brush, I dampen the board with a wash of clear water so the ink will spread when applied and result in a very soft edge on the tones.

Step 3. *(Above)* Mixing up a medium tone with the water-soluble ink and water, I add tones quickly before the board dries, so the tones will spread. Again, the line drawing doesn't dissolve or smear since it's done with the waterproof ink.

Step 4. *(Left)* When I don't want the ink wash to spread, I apply the tone without dampening the board. This is how I'm doing the foliage here.

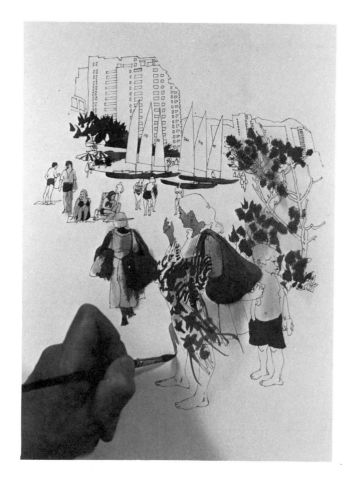

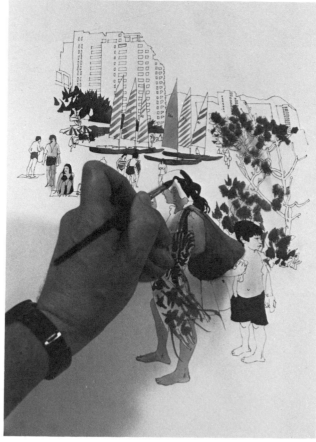

Step 5. *(Above) I dampen the area of the foreground figure's dress and of the foliage behind the boy. After I wait for the board to almost dry, I apply the tones. Thus the washes won't spread too much and will remain in the areas I want them. Next, I add flat tones to the girl's skin without wetting the board first, so the wash won't run outside the lines.*

Step 6. *(Above right) I add the solid black areas using water-soluble ink straight from the bottle without any diluting.*

Step 7. *(Right) I bring out the background mountains with a very dark tone and render the final touch with the addition of the skin tone on the boy.*

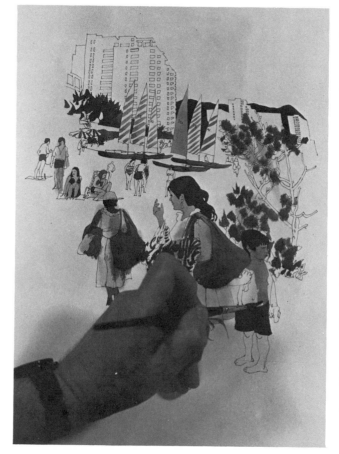

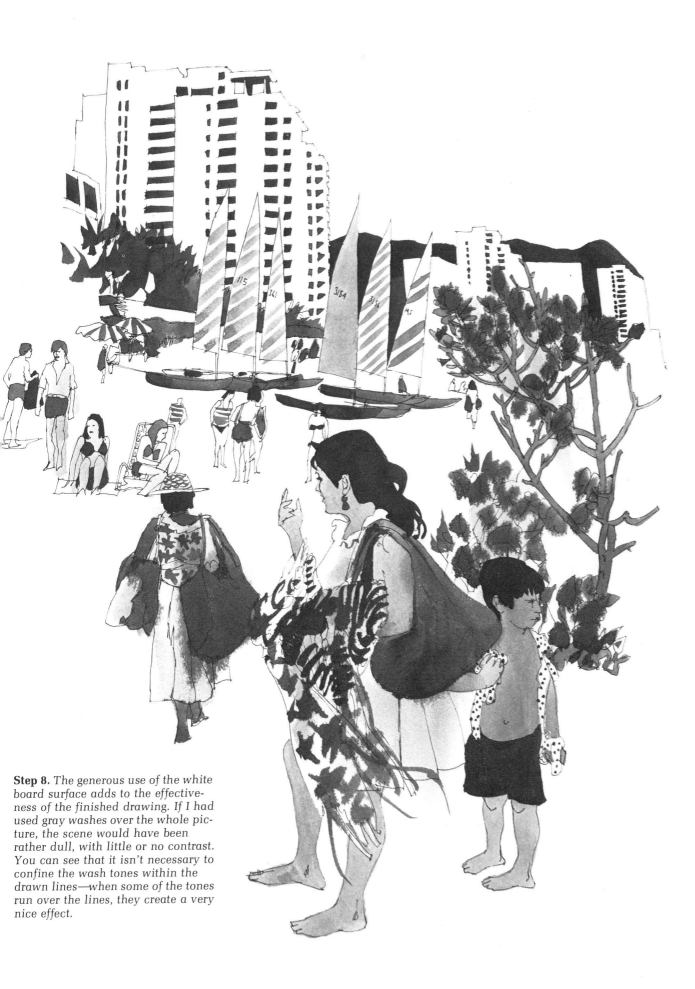

Step 8. *The generous use of the white board surface adds to the effectiveness of the finished drawing. If I had used gray washes over the whole picture, the scene would have been rather dull, with little or no contrast. You can see that it isn't necessary to confine the wash tones within the drawn lines—when some of the tones run over the lines, they create a very nice effect.*

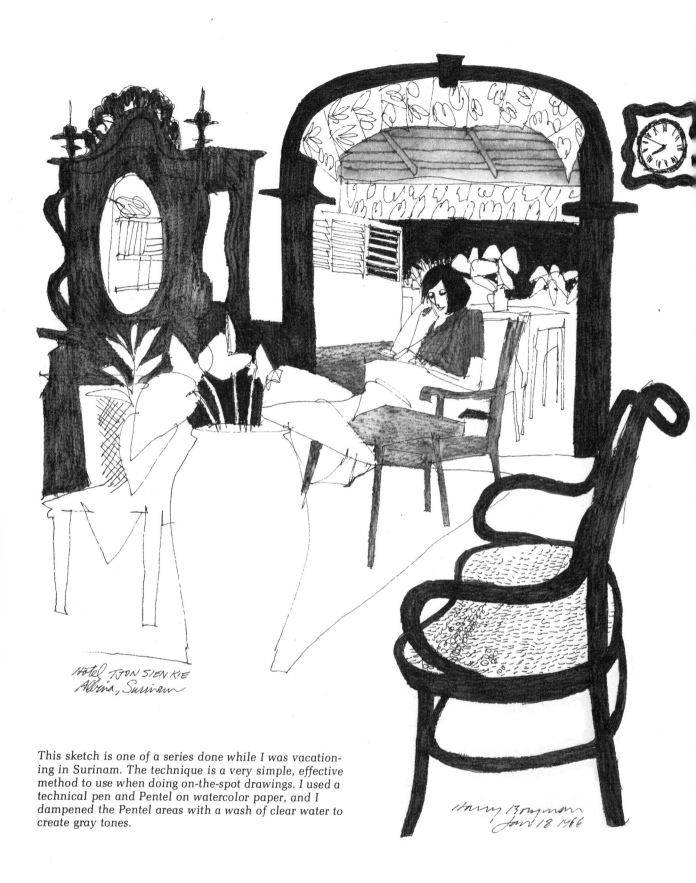

Hotel TJON SIEN KIE
Albina, Surinam

This sketch is one of a series done while I was vacationing in Surinam. The technique is a very simple, effective method to use when doing on-the-spot drawings. I used a technical pen and Pentel on watercolor paper, and I dampened the Pentel areas with a wash of clear water to create gray tones.

Harry Borgman
Jan 18 1966

MISCELLANEOUS TECHNIQUES

There are many unusual papers and boards that you can use for ink drawings. Mechanical tones and printed texture sheets that can be transferred to artwork are also available. In this chapter I discuss and use many of these unique boards and unusual tools, including a variety of pencils, marking pens, and crayons that you can combine with pen and brush drawings. Experiment with the following techniques to familiarize yourself with the boards, papers, and other items at your disposal.

A good quality layout paper is an excellent surface for ink or Pentel drawings. I drew this example with a Pentel pen and put the heavy accents in with an Eberhard Faber Markette pen. Being transparent, the layout paper enables you to draw or trace over a previous drawing, changing or correcting it until you get the desired effect.

I rendered this group of drawings—done for Universal International Tours Inc., a travel firm—with a Pentel pen and a Magic Marker for accents. Using layout paper is a very fast technique, as it eliminates the step of transferring a drawing to illustration board. In the advertising business, any time you can save may be very important, especially when you're coping with an overnight deadline—a rather common occurrence. Drawings done on layout or tracing paper can be taped or rubber cemented to a piece of mount board when you're finished.

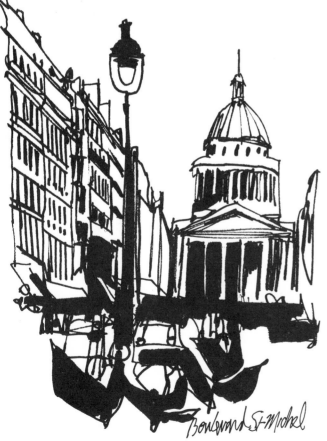

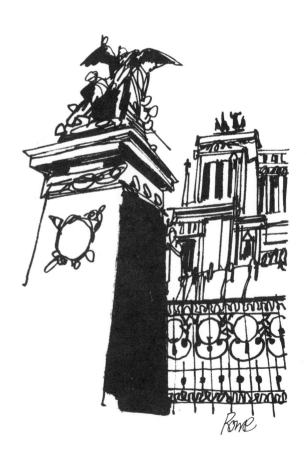

A brush drawing on Schoeller paper. I added the gray tones with a lithographic crayon. This is a good method for getting a gray tone on a line drawing that's going to be reproduced. When you use the crayon lightly, it barely touches the paper surface and leaves a very light tone. If you bear down harder when drawing, the result is a darker tone. You can also build up gradually until you reach the desired tone.

A drawing on a watercolor block. I used a technical pen for the basic drawing and a Pentel pen for the tone. I began by washing clear water over the Pentel, dissolving the tone into gray washes. I find this to be a very useful technique for on-location drawing. I drew this in the village of Onekai on the Marowijne River in Surinam.

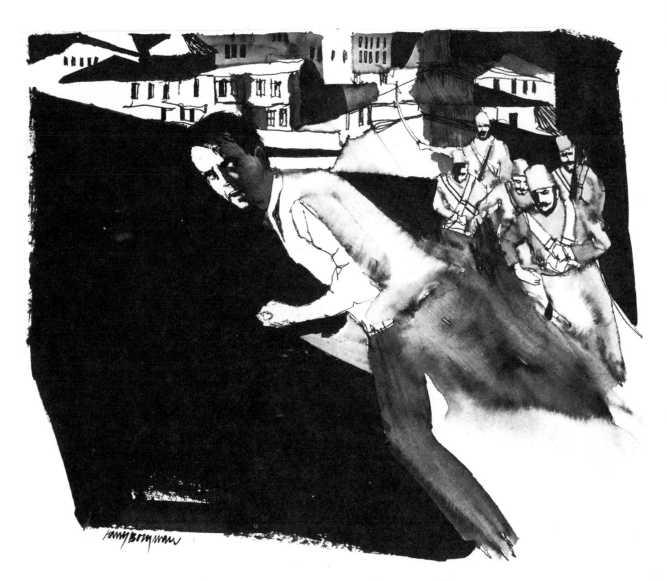

(Above) A drawing done for newspaper reproduction to illustrate a story on Onassis. I used a Pentel pen for all the line work and put the large black masses in with a brush and waterproof ink. Then I washed clear water over some of the areas to create a gray tone—the pen lines delineating the foreground figure were washed away at this time, adding greatly to the feeling of movement. This wasn't planned—it was just one of those happy accidents. The effect was just what the drawing needed.

Coquille board, which is available in different surface textures, has a special surface that is excellent for use with a litho crayon. This particular surface has a dot texture not unlike the texture found in a half-tone engraving used in newspaper reproduction. You can easily draw on this surface with a pen or brush, and then add the gray tones with a litho crayon or a china marking pencil.

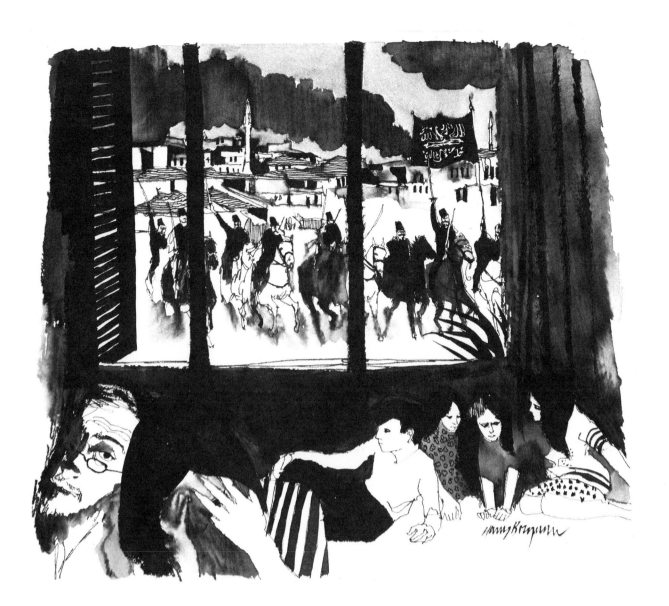

(Above) Again, I put in the very dark, solid areas of black with waterproof ink and a large brush, so they wouldn't dissolve when I washed the water on. I did most of the thin line work with a Pentel—the lines on the horses dissolved with the wash and added to the feeling of motion.

This is a Coquille board with different surface texture than the one in the previous example. I did this drawing with a brush and added the tone with a litho crayon.

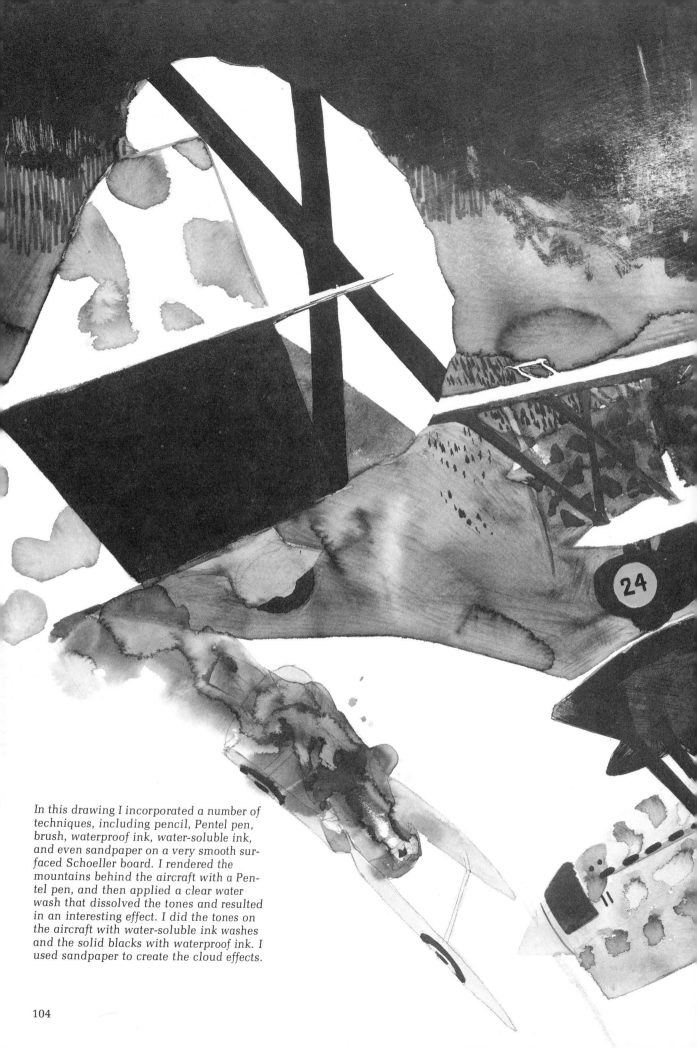

In this drawing I incorporated a number of
techniques, including pencil, Pentel pen,
brush, waterproof ink, water-soluble ink,
and even sandpaper on a very smooth sur-
faced Schoeller board. I rendered the
mountains behind the aircraft with a Pen-
tel pen, and then applied a clear water
wash that dissolved the tones and resulted
in an interesting effect. I did the tones on
the aircraft with water-soluble ink washes
and the solid blacks with waterproof ink. I
used sandpaper to create the cloud effects.

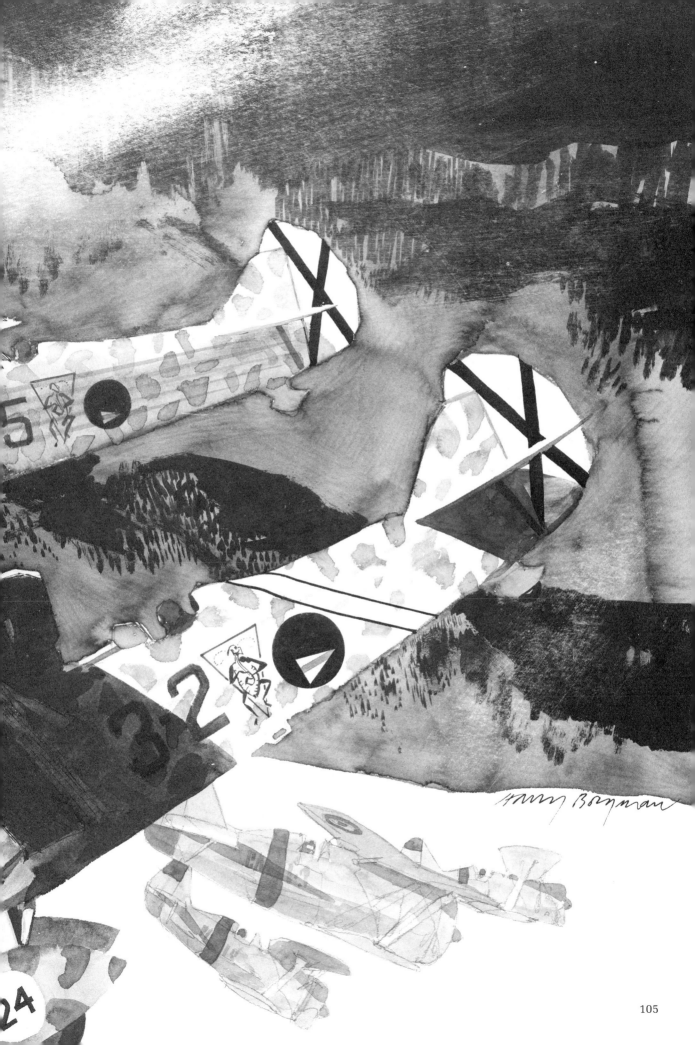

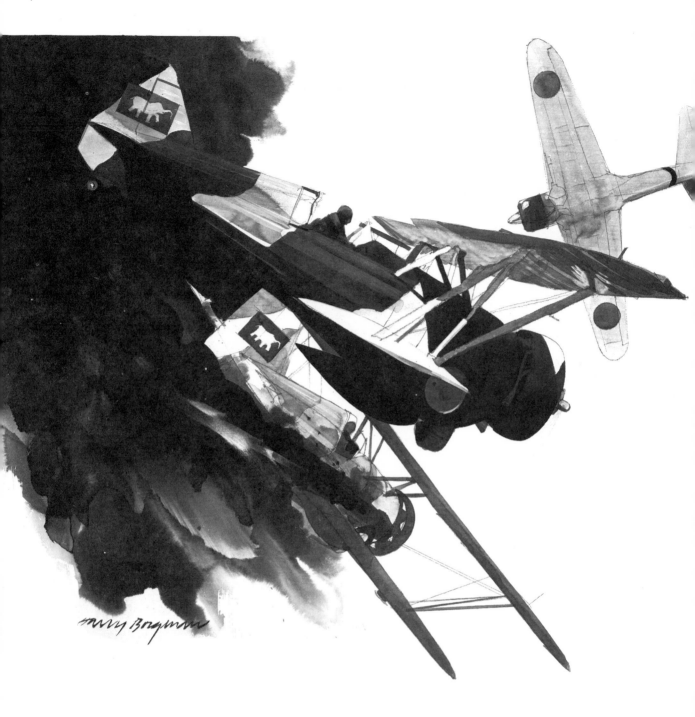

This scene depicts a clash between the Royal Thai Air Force and a Japanese
Zero fighter plane. I drew on Crescent No. 200 smooth illustration board thinly
coated with Liquitex gesso. Liquitex gesso, which has an acrylic polymer emul-
sion base, is generally used to size and preserve canvas for oil painting. I
thinned the gesso with water and applied it to the board with a large sign-
painter's brush. When dry, a gesso-coated board takes pencil very well, as
the resulting surface has a slight texture. I added the washes and solid blacks
with acrylic paint.

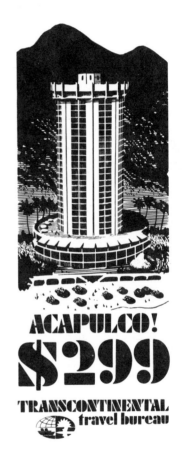

ACAPULCO!
$299

TRANSCONTINENTAL
travel bureau

Scratchboard is another unusual surface for ink drawings—the board has a special coating you can cover with ink and then scratch through. As you scratch back into the white, you get both tones and whites. The effect is very much like a woodcut or engraving. A good deal of careful planning is necessary to do a successful scratchboard drawing, because the surface is easily damaged from overworking. Therefore, to begin you should do a well-planned drawing in pencil on tracing paper and then transfer it onto the scratchboard by projecting the design or by using a graphite sheet. Put the solid blacks and linework in with a brush and allow them to dry thoroughly. Add the whites by scraping the board surface with an X-acto knife or a scratchboard tool. You can achieve very crisp, clean effects using this technique.

In these particular drawings, I did all the lines with a ruling pen and waterproof ink. I put the solid blacks, windows, trees, and mountains in with a brush. Then I cleaned up the drawing and added textures to the grass and windows with a scratchboard tool. Please note that you must let the ink dry completely before you scratch into it—you can't work the board properly if it's still wet or even damp. Also, notice how well the drawing reduces.

This drawing shows the variety of materials and textures that you can make in the scratchboard technique. This illustration is composed primarily of black with a minimum of white areas and lines. I put in the blacks very carefully with a brush and then allowed them to dry thoroughly. Then I scratched the tones on the front of the bowl, the rice, and the reflections on the bottle in freehand with the scratchboard tool. I created the textures on the inside of the bowl, parts of the bottle, and the chopsticks with the aid of French curves and a triangle. The lettering and trademark were my final touches.

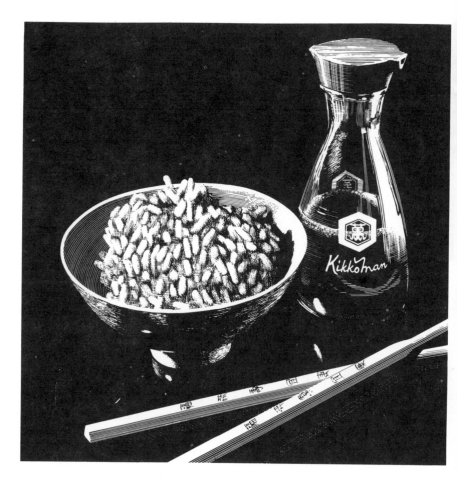

An illustration done for American Motors, rendered on canvas board. It's difficult to transfer drawings to canvas board by tracing with a graphite sheet, so I projected the photographs of the vehicles directly onto the board and drew with an Eberhard Faber Markette pen. Then, I put the washes in with acrylic paint.

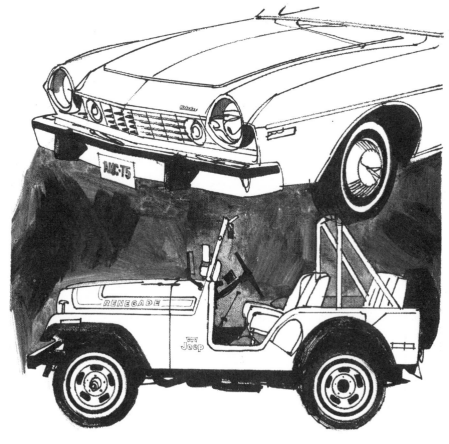

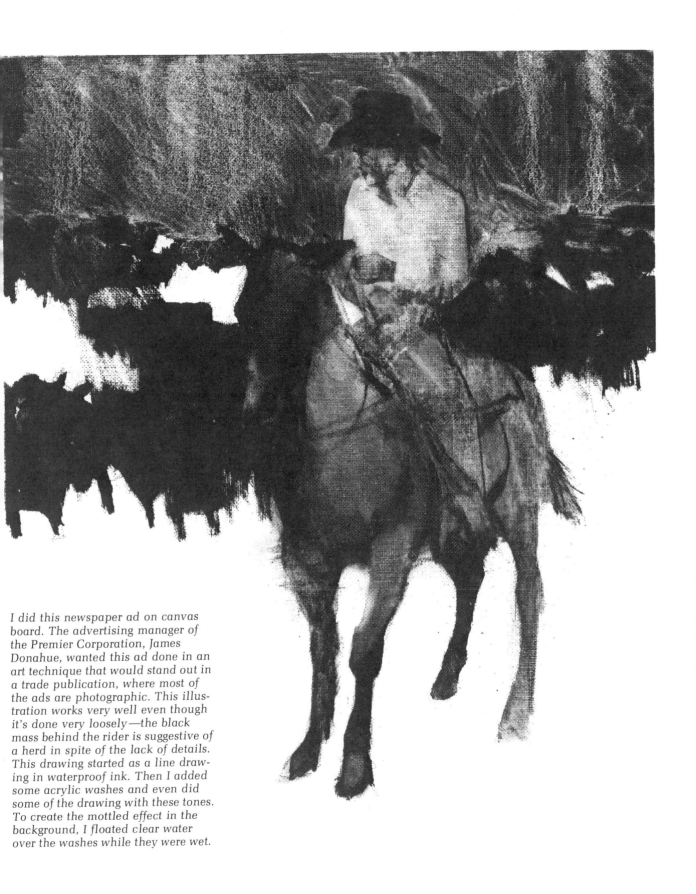

I did this newspaper ad on canvas board. The advertising manager of the Premier Corporation, James Donahue, wanted this ad done in an art technique that would stand out in a trade publication, where most of the ads are photographic. This illustration works very well even though it's done very loosely—the black mass behind the rider is suggestive of a herd in spite of the lack of details. This drawing started as a line drawing in waterproof ink. Then I added some acrylic washes and even did some of the drawing with these tones. To create the mottled effect in the background, I floated clear water over the washes while they were wet.

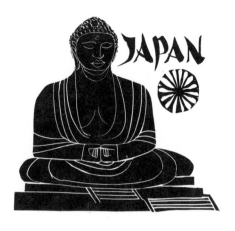

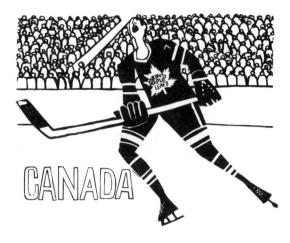

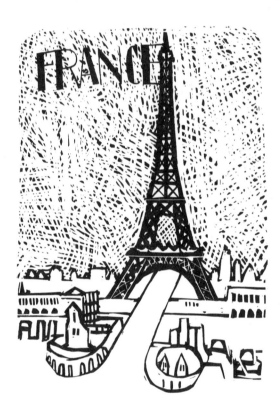

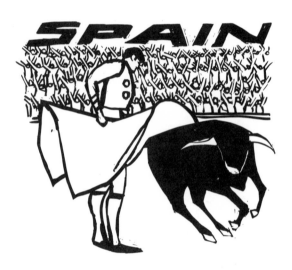

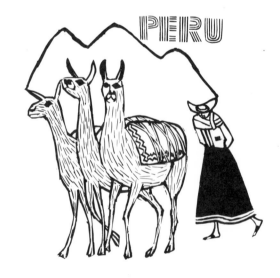

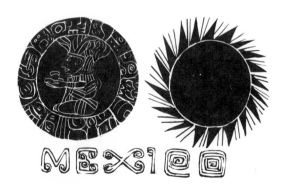

I made these drawings for a story in a magazine, Ward's Quarterly. They're handled in a very decorative, almost cartoonlike manner. I used a brush for all the linework and then cleaned up the lines with a scratchboard tool. I cut some of the textures into solid black using a cross-hatch technique, as on the France illustration.

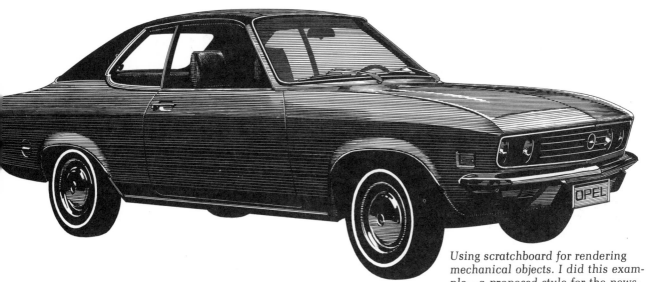

Using scratchboard for rendering mechanical objects. I did this example—a proposed style for the newspaper ad automotive art—as a sample for McCann-Erikson Inc., the advertising agency for the Opel account. I began the drawing by tracing a photostat of the car onto the scratchboard, and then very carefully inking the outline with a technical pen. Then I put in the large black areas with a brush. I created the tone on the side of the car by cutting white lines into the black (after it dried) by ruling the scratchboard tool with a triangle. If you make a mistake when you do it, you can repair it by re-inking the area and scratching a new tone in. I did the car interior in a more freehand manner to capture the feeling of the leatherlike material on the seats—I used a brush almost entirely, and I cut many of the tones in with the scratchboard tool. The smaller reproductions beneath the larger ones show how well these drawings hold up under reduction. The key to good reduction is to keep the lines that make up the tones far enough apart on the original drawing so they don't fuse together and reproduce as a solid mass when reduced.

Simulating a woodcut or engraving with scratchboard. First I draw the black lines boldly with a brush, and then I clean them up with the scratchboard tool. Even though it's a great help to do a good sketch to use as a guide when doing the rendering, a few slight mistakes here and there help convey the feeling of a woodcut. This drawing was done for an Ethyl Corporation ad.

Another example of the woodcut technique on scratchboard. I planned the drawing very carefully in pencil on tracing paper and then transferred it to the scratchboard using a graphite tracing sheet. I did the rendering with a brush and waterproof ink. I cleaned some of the lines up and added a few white lines to give the proper effect. Next, I drew some black lines in the ground area, scratching through them to add to the woodcut feeling.

Here's a very small, spot drawing from the Ethyl ad series. The drawing is almost solid black with a few white lines scratched in to indicate the masts, sails, and other details of the ship. I then outlined the whites in black with a brush, giving the drawing a distinct woodcut feeling. The white lines in the waves follow the form to add to the effect of motion.

Crowquill pen and bristol board. You can simulate an engraving using this pen, and I did so here with 2-ply bristol board. First I drew a comprehensive sketch on tracing paper with a Pentel pen to establish exactly where the tones would go. Then I traced the sketch onto the scratchboard and inked, using the sketch as a guide. This drawing works well both small and large.

112

All drawings for black and white line reproduction need not be drawn with a pen or brush. Many times I will use a regular pencil or Wolf carbon pencil. A pencil drawing has a certain flair and freedom that's hard to achieve with a pen or brush. I did this one with a Wolf carbon pencil grade BBB on a smooth-surfaced Crescent illustration board. When I finished drawing, I sprayed the design with fixative to prevent smudging. Then I put in blacks with waterproof ink. Many board surfaces can be used with pencils—rough watercolor papers, rice papers, and even textured Coquille boards. You can always add ink or acrylic washes for gray tones.

Here's the same drawing with tones added with a product called Zipatone. Zipatone is a printed tone sheet with an adhesive backing that will adhere to most any drawing surface. These sheets come in a great variety of textures, dots, and linear tones. Some of these tones are graded by percentages such as 10%, 20%, 30%, and so on, up to 90%. There's even a sheet with a graduated tone from 10% to 90%. Zipatone is a good method for adding tones to drawings for line reproduction.

Another example of the same drawing using a Zipatone sheet over the background—you can change the character of a drawing completely by utilizing these tones in different ways. Other fine shading products are made by Paratype, MicoType and Letraset. Letraset makes an interesting product called Instantex, a rub-down sheet that transfers areas of tone to illustrations.

Demonstration 7. Ink Lines and Instantex

Instantex is a dry transfer system for adding various textures and tones to a drawing. The 10″ x 15″/25.4 x 38.1cm printed sheets are available in a variety of patterns as well as solid black and can be rubbed down on most any board and paper surface with a stylus or burnisher. You can even combine the different Instantex sheets or use them over one another for special effects.

This demonstration shows the development of an illustration, a newspaper ad for P & G telephone, that was an assignment for Ketcham, McLeod and Grove, Inc. of Pittsburgh, Pennsylvania. Jim Fox, the art director, telephoned to see if I was available to handle this assignment and then mailed a layout to me. Before beginning my sketch, though, I called Jim to discuss the requirements of the ad in detail.

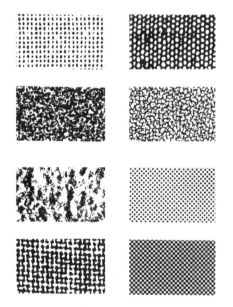

Step 1. *Here's the layout that I'll use as a guide for my illustration. A few of the 20 patterns available in Instantex, a unique dry transfer system, are shown at left.*

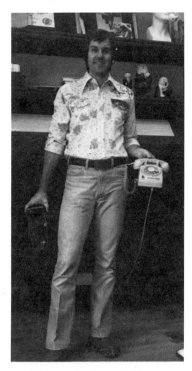

Step 2. First I make a very rough diagrammatic sketch of the illustration, top, to use as a guide for taking the necessary reference photos, bottom. I enlisted my wife—Jeanne—some friends, and even my dog, Angus, to model for these Polaroid pictures. I took several shots of each to have a variety of poses to choose from. Polaroid cameras work very well, because you can see immediately whether you're capturing the right poses and expressions.

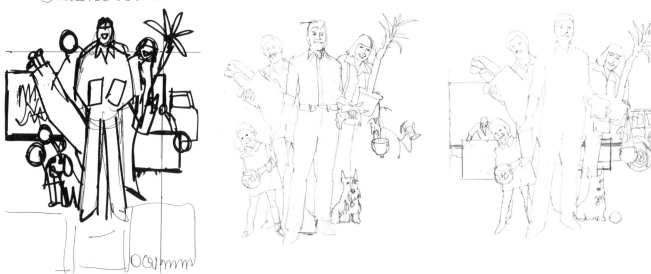

Step 3. *After I receive a phone call from the art director advising me of a change in ad size, I do a new sketch, left, to see how the elements in the picture will work in the new size. Next, I do a very loose drawing in pencil on tracing paper to establish the position of the figures, center. Right, I revise that sketch further by drawing directly over the first one on tracing paper and moving the figures around until they look right. I use this tissue sketch as a guide to position the figures on my final drawing.*

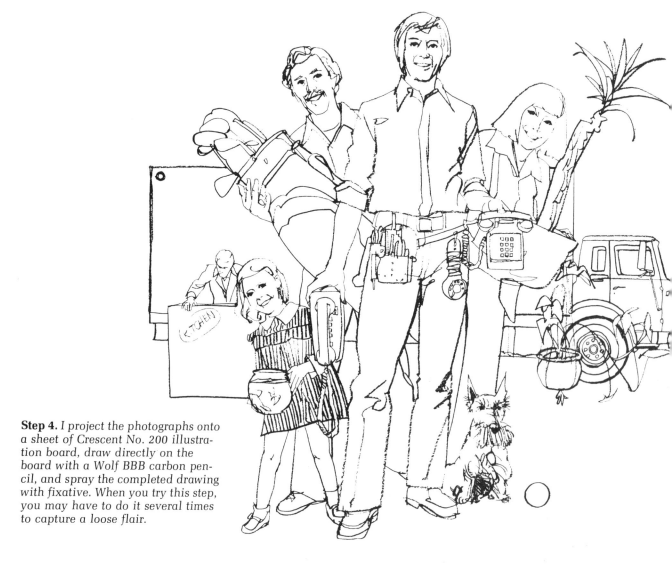

Step 4. *I project the photographs onto a sheet of Crescent No. 200 illustration board, draw directly on the board with a Wolf BBB carbon pencil, and spray the completed drawing with fixative. When you try this step, you may have to do it several times to capture a loose flair.*

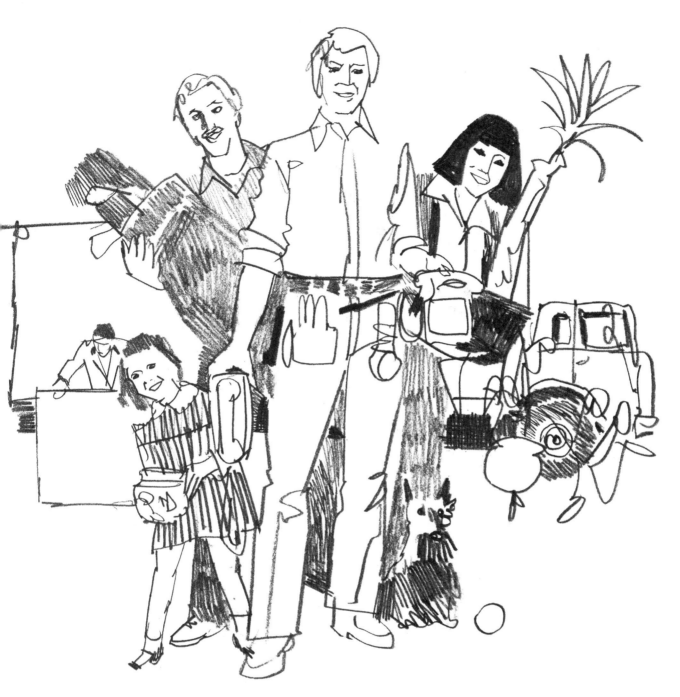

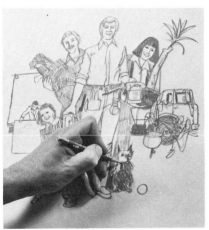

Step 5. This is the tone drawing, done on tracing paper, that I use as a guide for adding the grays to the illustration.

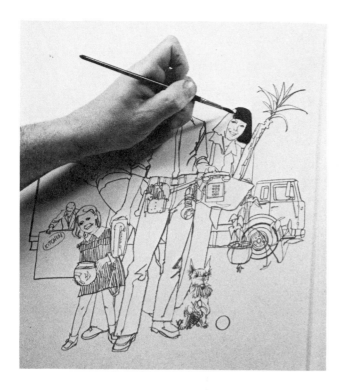

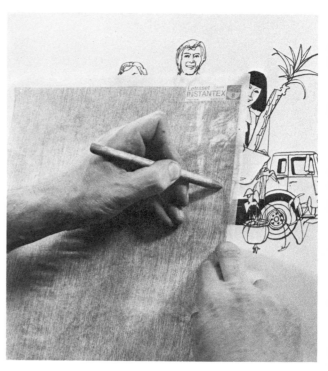

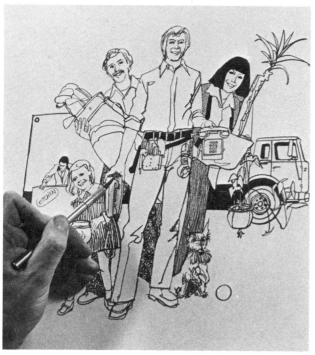

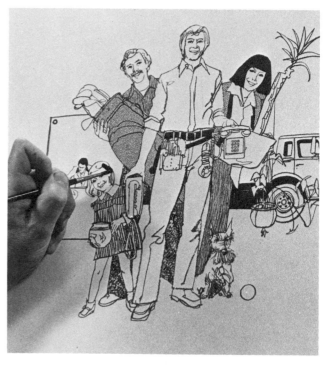

Step 6. *Top left, I put in a few of the solid black areas with waterproof ink. Note the sketch used as a reference at the right. Top right, I position the Instantex sheet over the area that requires tone and rub with a wooden burnisher. When you do this, try to keep the tone within the confines of the area to be shaded. You can always lift the sheet to check and then put it back down if the area needs more rubbing. Any of the Instantex tone that overlaps the designated area can easily be scraped away with an X-acto knife, above left. And you can remove other unwanted areas with a piece of masking tape. Above right, I add still more blacks, and the drawing nears completion.*

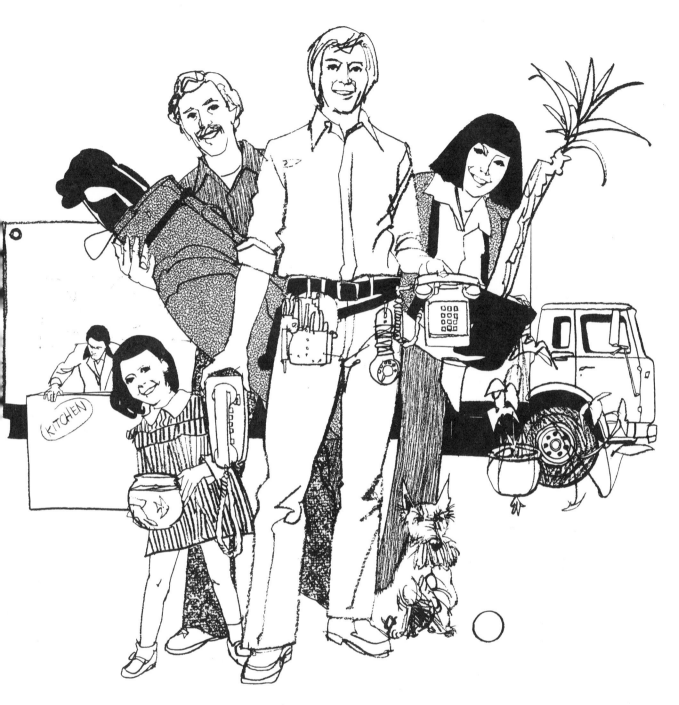

Step 7. *The final drawing—the tones separate very well in spite of their closeness in value because the textures that make up the tones are quite different.*

Demonstration 8. Scratchboard Used for Realistic Drawing

Scratchboard, a very unique surface, enables you to work in a number of styles that you couldn't do on other surfaces or with other methods. This demonstration covers using scratchboard for drawing in a realistic style—the two ads described were done for small newspaper ads.

Scratchboard is an excellent medium for small, crisp, well-defined drawings. Its surface is quite delicate and can easily crack if bent, so it's wise to either tape or rubber cement the scratchboard sheet to a piece of double-weight mount board. Be careful to mount the correct side face up —it's easy to mistake the back surface for the front working side. I have done this on occasion, and it's quite disconcerting to find you have gone through all the trouble of tracing a drawing on the wrong side of the board! The working surface is chalky and duller looking than the back side. You can also check by bending a small piece of the corner —the scratchboard side will show a distinct crack, while the other side merely creases.

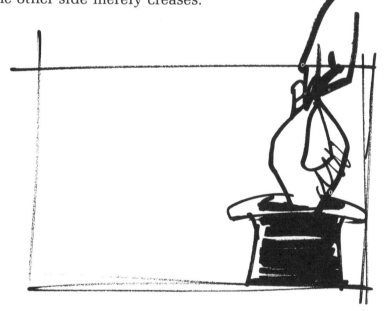

Step 1. *This is the actual layout I'll work from when doing this illustration. The art director wanted me to interpret the words "banquet magic," and he wanted the drawing handled in a realistic style rather than a decorative or stylized one.*

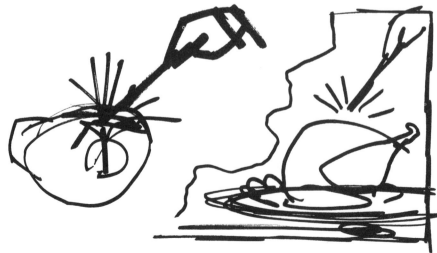

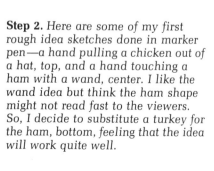

Step 2. *Here are some of my first rough idea sketches done in marker pen—a hand pulling a chicken out of a hat, top, and a hand touching a ham with a wand, center. I like the wand idea but think the ham shape might not read fast to the viewers. So, I decide to substitute a turkey for the ham, bottom, feeling that the idea will work quite well.*

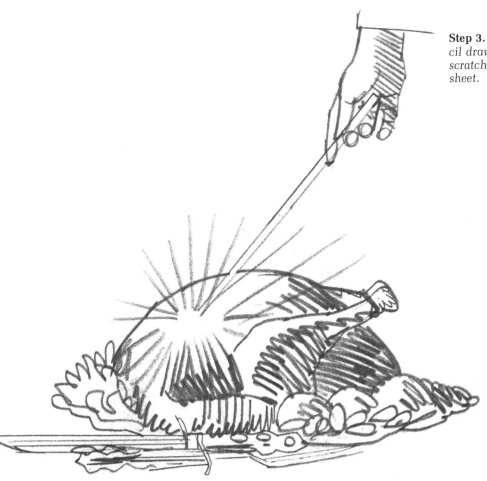

Step 3. *After working up a final pencil drawing, I trace it down on the scratchboard with a graphite tracing sheet.*

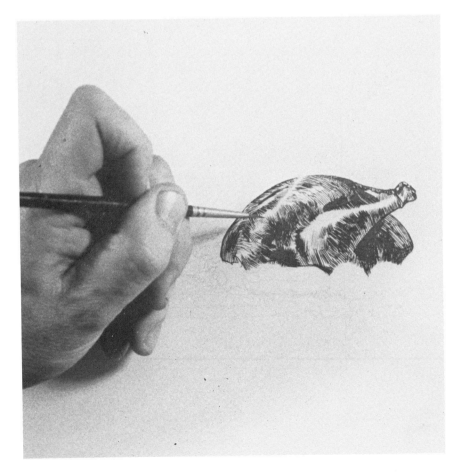

Step 4. *I start with a No. 1 red sable brush and waterproof ink. I give careful attention to form and to the various textures on the turkey.*

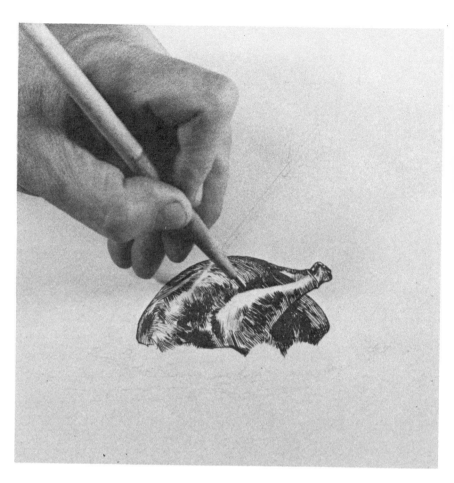

Step 5. To get a clean edge on top of the drumstick, I scrape the edge with a scratchboard tool, above. Right, I add a tone over the scraped area with a brush.

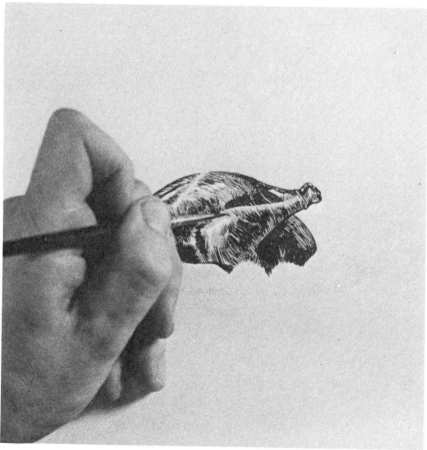

Step 6. *Above, I continue very carefully, hoping to keep the final cleanup and scraping to a minimum. The board will take only so much scraping without damage to the surface—usually you can go over an area just twice before you damage the surface, so it's best to have a minimum of alterations or corrections. Left, I put in the tones in the knife as well as the potatoes and greens by the brush ruling method.*

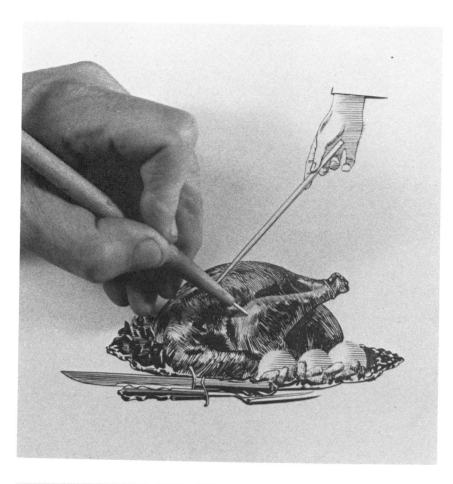

Step 7. *I scrape highlights in on the turkey, above, and put in the flash at the end of the wand by resting the scraping tool against a ruler, right. This is very much the same as brush ruling.*

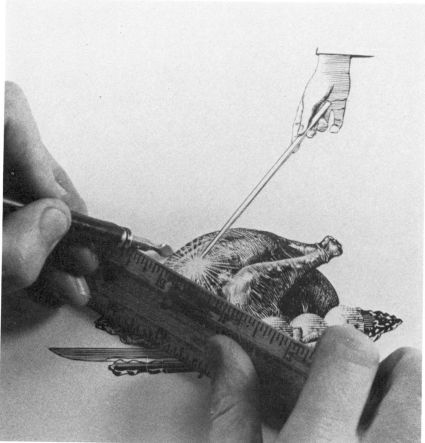

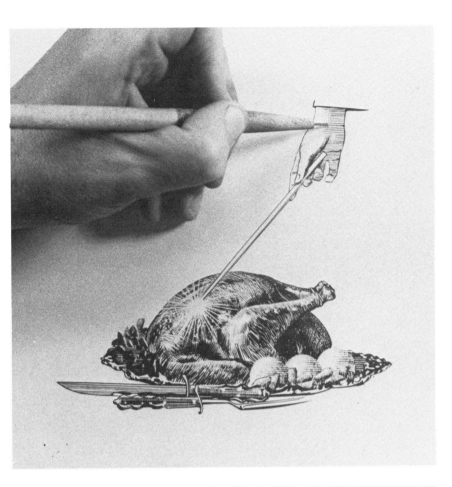

Step 8. *Above, I soften the tone on the hand and give it a rounded shape by scraping white lines through the black ones. Then I scrape in the last few highlights, left.*

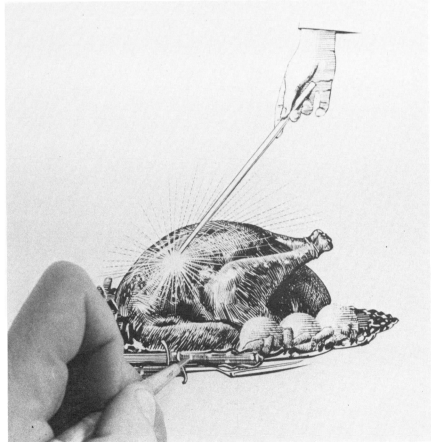

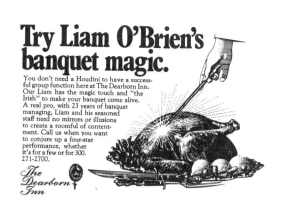

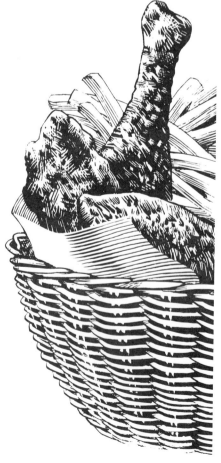

Step 9. *(Right) This is the completed drawing as submitted to my client and as it appeared in the completed ad. The art director decided that the illustration would work better by shortening the wand, bringing the hand closer to the turkey. This allowed the illustration to be used slightly larger, making it stronger.*

Another layout of an ad in the same series. This time, the subject is chicken in the basket. I decided against using the looking-down view on the layout—I thought the ad would come off better if I showed more of the basket. The viewer would get the idea much faster because of the distinctive basket texture. Small ads like these can be a real problem, as space limitation greatly curtails the illustration possibilities. I planned this drawing carefully, rendered it with a brush and kept the scraping to a minimum. I only used the scratchboard tool to clean up a few edges and to put a few tones on the chicken.

Demonstration 9. Scratchboard Used for Decorative Drawing

This drawing, which looks like a woodcut, is used as a spot drawing in a brochure I produced for American Motors. The client wanted to dress up a spread pertaining to our country's bicentennial — I decided to draw the American eagle in a woodcut style reminiscent of the colonial days.

Step 1. *I start the drawing by doing several very rough sketches, such as the one on the right, with an Eberhard Faber marking pen. My final sketch is in the center. At the bottom is the more detailed sketch I developed by drawing over the previous one with tracing paper.*

Step 2. *I do a tight pencil sketch on tracing paper over the marker drawing, above. Right, I tape the pencil drawing to the scratchboard and trace it using a graphite tracing sheet. Below right, I begin inking with a No. 1 red sable brush—the inking is rather crude to simulate a woodcut.*

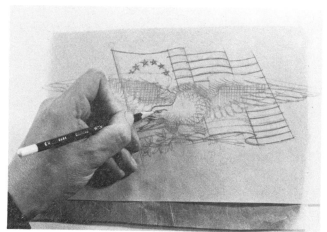

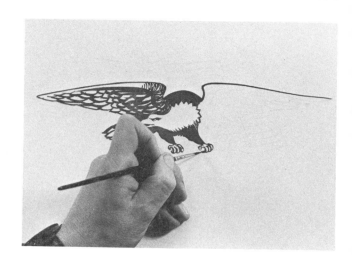

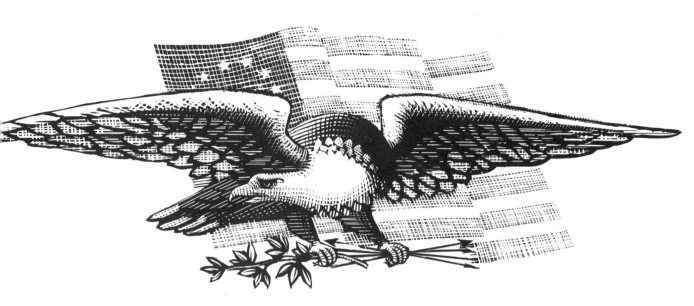

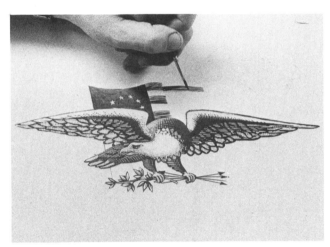

Step 3. *I scrape some of the tones on the upper parts of the wings and the eagle's head with the scratchboard tool and then ink the flag with the brush, left. You really don't have to be as careful when doing this type of a drawing as when you're doing a realistic one, since any roughness helps convey the feeling of a woodcut. Below left, I scrape the tones of the flag in with the scratchboard tool. Above, the final drawing—it's rather crude in actual size but holds up well in the smaller reproduction, below.*

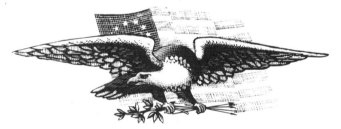

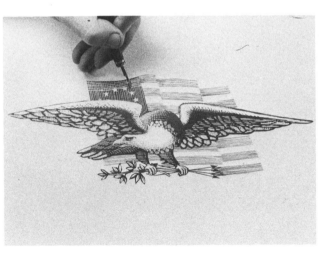

Demonstration 10. Ink Lines and Pentel Washes

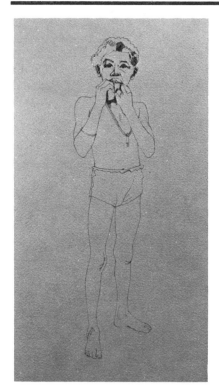

Drawing with a technical pen on a watercolor block and putting in the gray tones with a Pentel pen is a fast and easy method of working. This is the technique I often use when I'm on a trip or just doing outdoor sketching — it doesn't require carrying around a lot of equipment. Usually I do the ink line drawing and add the Pentel tones on the spot. Then, back at the hotel or my studio, I add the clear water that creates the washes from the Pentel tones.

This technique works particularly well on a rough-surfaced paper like watercolor blocks or pads. I made the drawing for this demonstration from photographs taken in a village in Surinam. I did a few drawings in the village as well—it's a great way to get to know people.

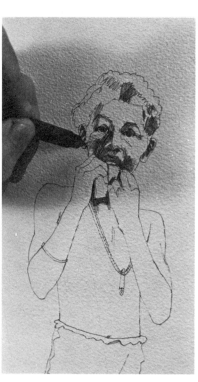

Step 1. *I started out by doing a line drawing on an Arches watercolor block with a technical pen, top. Above, I add some of the facial details. Right, I complete the drawing, using mostly linework, although I shade a few of the areas where the shadows fall with a slight tone.*

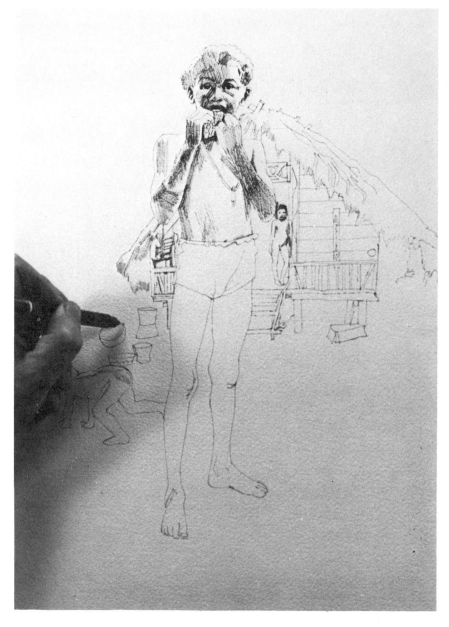

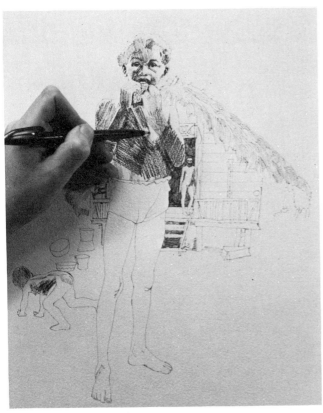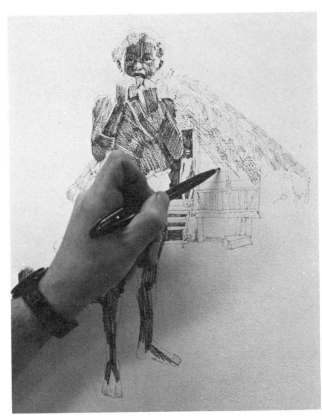

Step 2. *I use a Pentel pen for the final gray tones, left. Pentel, used on this rough surface, creates a line similar to that of a charcoal pencil. Right, I draw a tone very lightly on the front of the hut. Thus the final wash will be a lot lighter in value than the areas where I applied the Pentel more heavily.*

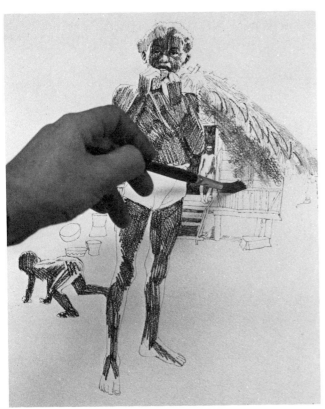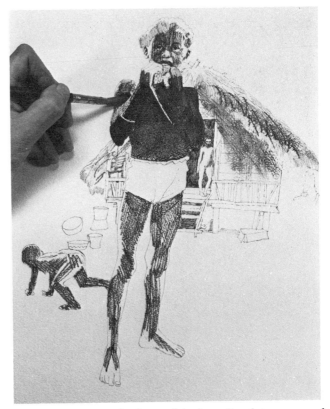

Step 3. *After I load a No. 10 red sable brush with clear water, I put a wash over the front of the hut, dissolving some of the Pentel and thereby creating a gray tone, left. Right, I dampen the figure of the girl with clear water—the resulting wash is very dark because of the intensity of the Pentel lines.*

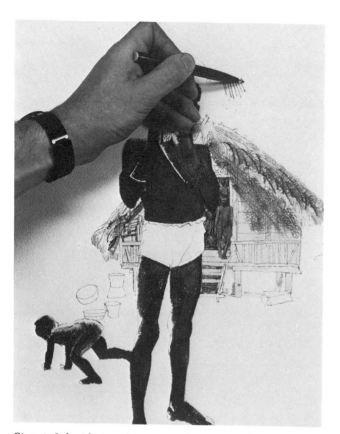

Step 4. *I decide to add some palm trees and indicate them quickly with simple Pentel strokes, left. Then, loading the brush with clear water, I draw over the lines to form the trees, right. The resulting washes create a convincing group of palm fronds.*

Step 5. *I add the very dark areas in the picture with the Pentel pen, left. Right, I apply a wash of water over these areas to create a near-black tone.*

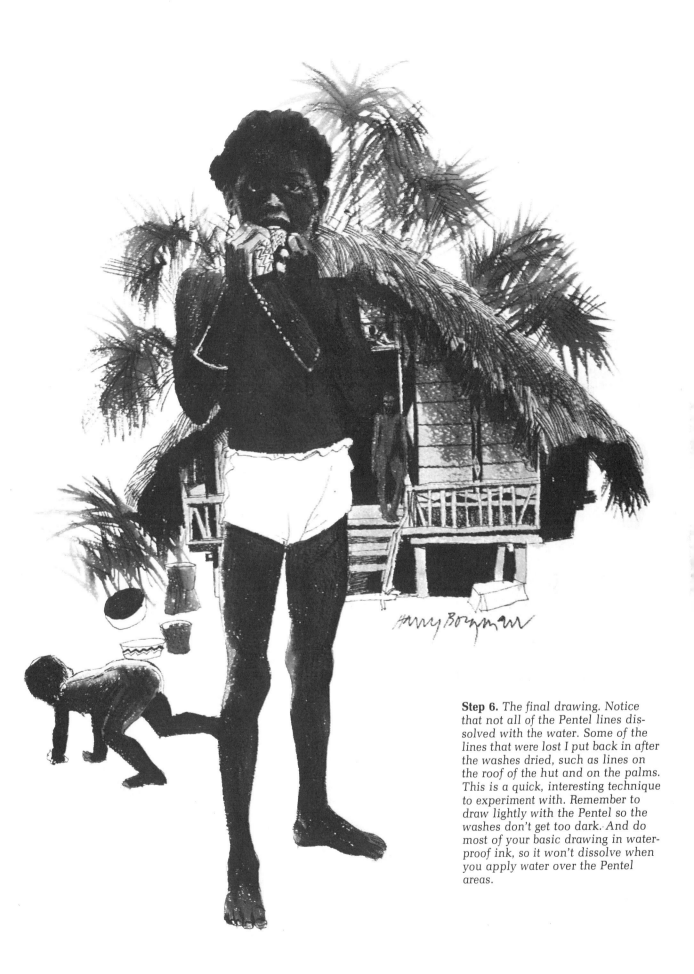

Step 6. The final drawing. Notice that not all of the Pentel lines dissolved with the water. Some of the lines that were lost I put back in after the washes dried, such as lines on the roof of the hut and on the palms. This is a quick, interesting technique to experiment with. Remember to draw lightly with the Pentel so the washes don't get too dark. And do most of your basic drawing in waterproof ink, so it won't dissolve when you apply water over the Pentel areas.

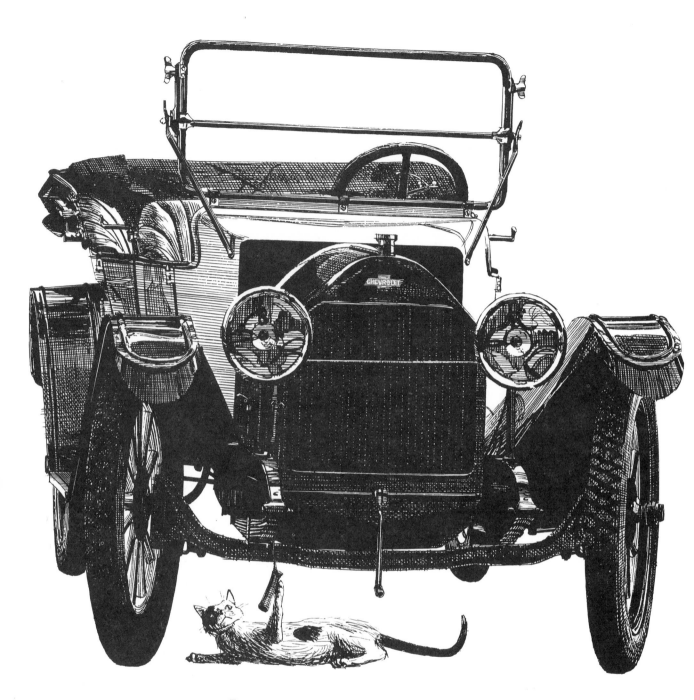

Try to put some life into mechanical subjects you draw—here I used a cat playing with the crank handle holder to bring a little action to an otherwise static picture. The brushstrokes in the headlights and fenders also help loosen up the mechanical rendering of this old Chevrolet.

CORRECTING INK DRAWINGS

You can always correct ink drawings by painting out unwanted areas with white paint, and then inking over the paint when it's dry. However, this isn't really the most satisfactory way to change an ink drawing, as the pen doesn't handle very well over paint, especially if the paint is thick. The result usually looks very messy. The best method for removing unwanted areas and lines is to use an ink eraser—and most good quality illustration boards hold up well when you use a fiberglass eraser. The surface remains undamaged and new lines can easily be drawn back in. An even faster, more efficient method is to use an electric eraser with which you literally grind away a portion of the illustration board surface. Erasing machines use eraser plugs that are available in various grades to meet every erasing problem. I usually use the gray eraser plug for removing ink lines and solid black areas of ink, and the pink eraser plug—which is less abrasive—for taking out more delicate lines and for removing washes without damaging the board surface so you can apply a new wash without any problems. The electric eraser is equipped with an automatic switch that starts the motor when it's tilted downward for use. It's probably the handiest tool I own. It has saved many an illustration from the wastebasket.

White paint—like the Winsor & Newton gouache permanent white in the tube at upper left—can be used to correct minor errors and to take out unwanted lines, but it's usually difficult to draw over the paint with the pen. To the right of the paint is an erasing shield, which can be very helpful when taking out small areas or when protecting adjacent areas from damage if you're using a fiberglass or electric eraser. The electric eraser, far right, is the best method to use for correcting ink drawings. Eraser plugs, lying in front of the paint and shield, are available in various grades and can be purchased singly or by the box. Underneath the plugs is a fiberglass eraser—it can be used on most high quality illustration boards.

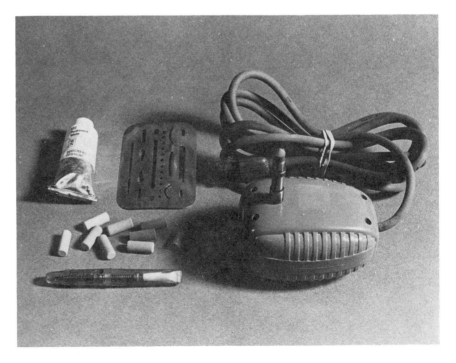

Demonstration 11. Using an Erasing Shield

This is a very professional method for correcting ink drawings. The result is a much better appearance than if white paint is used to correct mistakes.

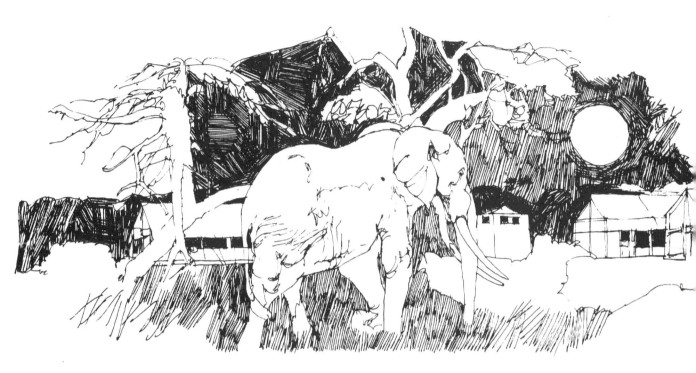

Step 1. (*Above*) *The drawing before it is corrected—I want to replace the tent on the extreme right with some foliage.*

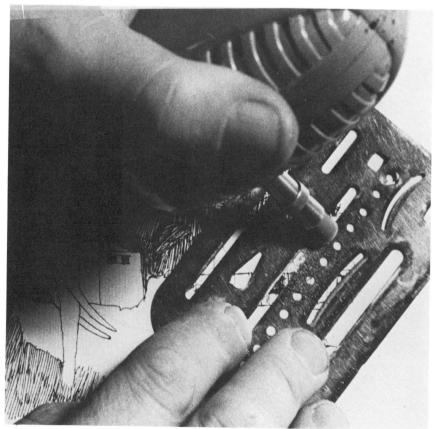

Step 2. *I use an erasing shield to remove the unwanted lines so the adjacent lines won't be damaged. Sometimes I have to go over an area two or three times before all the lines are erased and the area is clean. When you do this, take care not to grind through the board surface to the backing.*

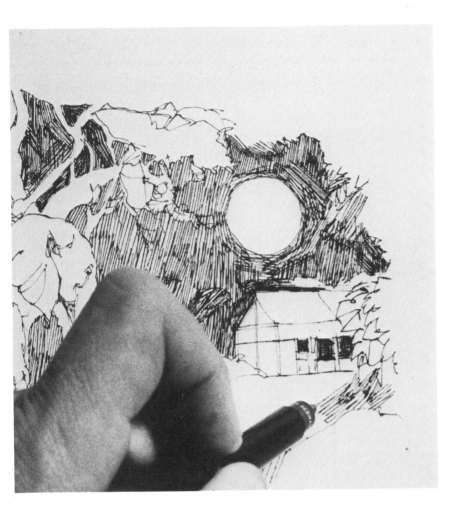

Step 3. *I draw over the area again easily as the surface isn't damaged.*

Step 4. *(Below) The corrected drawing looks perfect—there's little evidence that it has been reworked.*

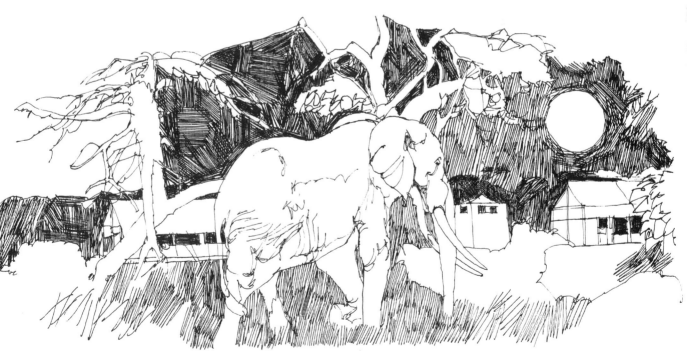

137

Demonstration 12. Using the Electric Eraser

The only way to correct a wash drawing is by using the electric eraser. You can't do it by using white paint because the paint will dissolve when you attempt to put a wash over it. And a fiberglass eraser cuts into the surface slightly, causing the new wash to go on unevenly. Please note that a wash drawing can best be corrected when it has been done on a high quality illustration board, such as the Strathmore board used here.

Step 1. *I use the electric eraser with a pink plug to remove the wash on the man's pants. I erase the area several times, until it's clean.*

Step 2. *The erasing shield minimizes damage to the adjoining areas.*

Step 3. *I use a drafting brush to wipe away the eraser particles—it's very important to have a clean board surface when applying the new washes.*

Step 4. *I draw the outline back in.*

Step 5. *The new washes go on quite evenly, because the board surface wasn't damaged by the erasing.*

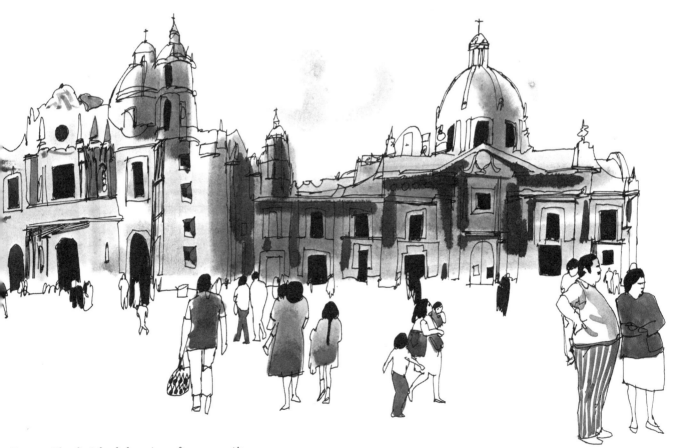

Step 6. *The finished drawing after corrections.*

Demonstration 13. Correcting a Scratchboard Drawing

Scratchboard has a very unique surface that allows you to scrape away unwanted areas. If you do this very carefully and don't scrape too deep, you can easily re-ink the area and even cut in a texture or tone. If you scrape off too much of the board surface, you damage the board — and it's doubtful you'll be able to save the drawing.

Step 1. *This illustration is nearing completion, but I don't think the buildings and the sky in the Hong Kong scene are working properly. The buildings just look too crude, and the lines in the sky are too fine for good reduction. As this illustration is to be used in a variety of sizes for newspaper reproduction, it has to be rendered bold enough for good reduction.*

Step 2. *(Below) I tape a sheet of tracing paper over the illustration and make a quick tracing of the area to be corrected. When I scrape out the unwanted area, I will naturally lose my drawing. By making this tissue, I can easily trace the drawing back in after scraping the area clean.*

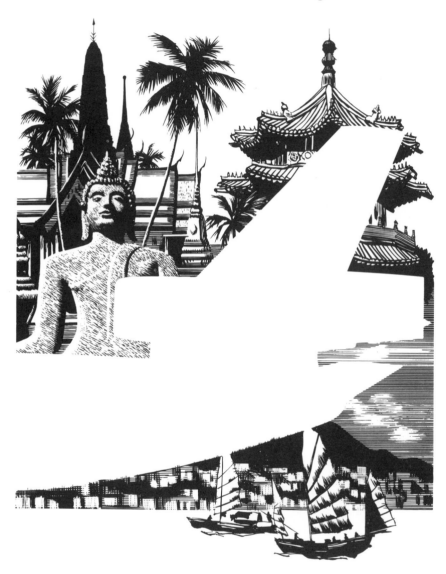

Step 3. *I remove the tracing paper and scrape the section of the drawing to be corrected carefully with a scratchboard tool. When you do this, be very cautious and don't scrape too deep—make sure the surface remains workable.*

Step 4. *(Above) After the area is scraped clean, I retrace my drawing using a graphite tracing sheet and a stylus.*

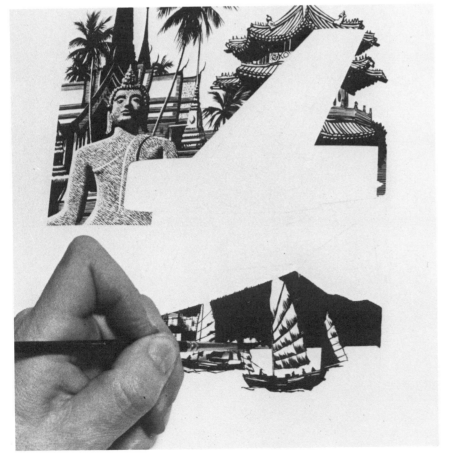

Step 5. *It isn't necessary to scrape the ink from the island, since the drawing in this area is basically done by scraping white lines into the black background. So, I just brush ink over this whole section. Then I must wait until the ink is thoroughly dry, as clean lines can't be cut into wet or even damp ink.*

141

Step 6. *I clean up the edge of the aircraft by cutting with a scratchboard tool—I guide the tool with a curve and triangle.*

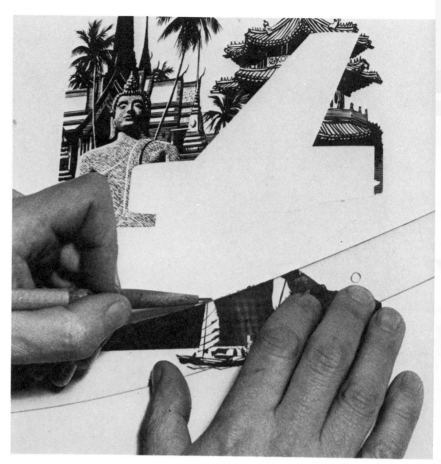

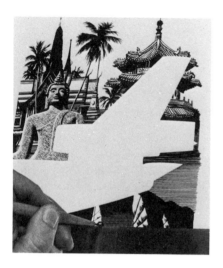

Step 7. *(Above) I scrape horizontal lines into the land area using a T-square as a guide. Then I rule a gray tone in the sky and allow it to dry. Gradually I build up the tones in the houses and buildings, putting in the black shadows and windows with a brush.*

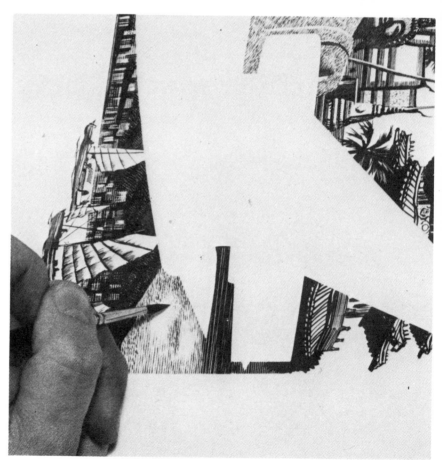

Step 8. *After scraping clouds into the sky, I again decide to change the whole character of this section. I feel that an overall texture made up of small brushstrokes will work better.*

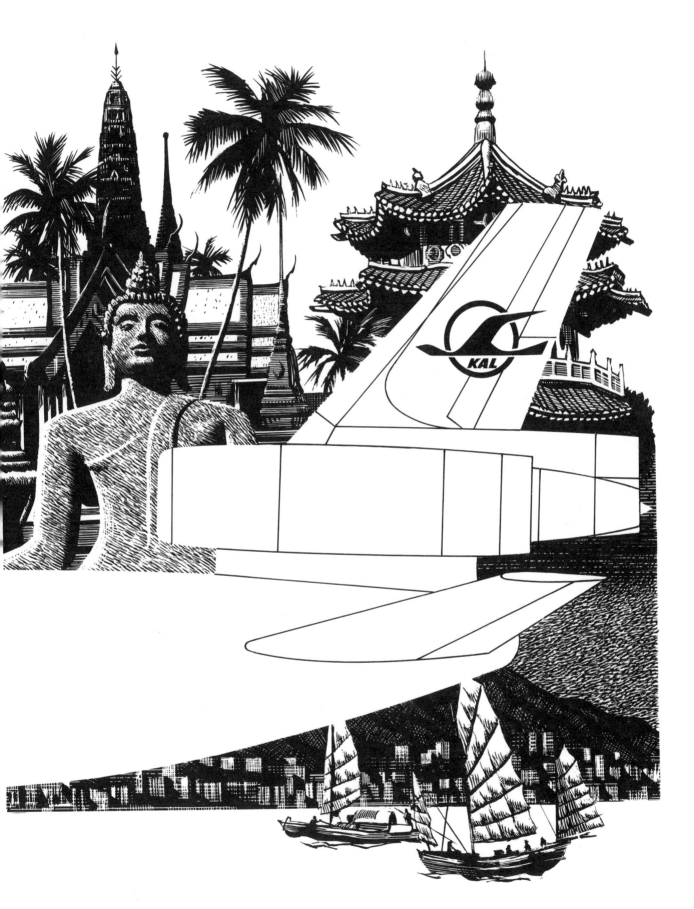

Step 9. *Here's the final art—all the lines will hold up very well even when they are reduced to the size of a newspaper ad. Reduction is often an important consideration when doing advertising artwork.*

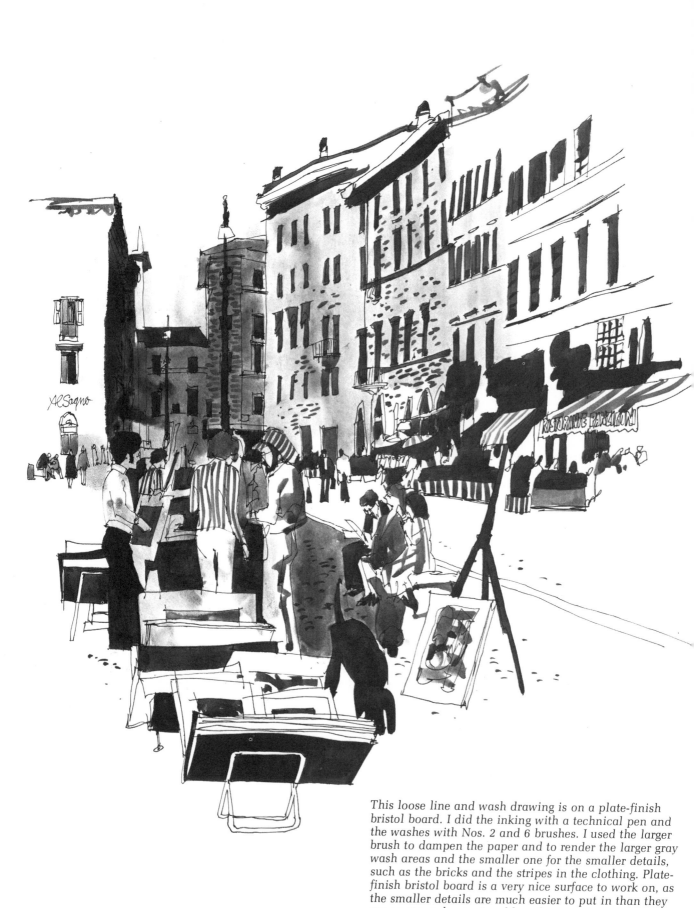

This loose line and wash drawing is on a plate-finish bristol board. I did the inking with a technical pen and the washes with Nos. 2 and 6 brushes. I used the larger brush to dampen the paper and to render the larger gray wash areas and the smaller one for the smaller details, such as the bricks and the stripes in the clothing. Plate-finish bristol board is a very nice surface to work on, as the smaller details are much easier to put in than they are on a rougher-textured board or paper.

TECHNICAL TIPS

In this chapter I'll discuss a variety of subjects—cleaning your tools, reference sources, camera equipment, making a graphite sheet, and using an opaque projector.

CLEANING YOUR TOOLS AND SHARPENING YOUR PENCILS

Keep a rag handy for wiping your pen points clean after you use them—an ink-encrusted pen won't function properly. You can clean points for technical pens with a pen-cleaning fluid that dissolves dried ink. This solvent will also remove hard, dry ink on brushes.

As you may know, it's much easier to draw fine details if you maintain a sharp needle point on your pencil. The best method I've found is to cut the wood away from the lead with an X-acto knife and sharpen the lead to a fine point with a sanding block.

REFERENCE AND RESEARCH SOURCES

Many artists have a reference file of photographs they've taken and of magazine picture clippings covering various subjects that they might need at a later date. This is a good idea for you. A fairly complete file, however, can take up quite a bit of room and requires a certain amount of time to keep up to date. My solution is a combination of a very small reference file and a good selection of magazines and books stacked on steel shelves in the basement. I picked most of them up at used book stores—*National Geographic, Sports Illustrated, Ladies' Home Journal, McCall's* and old *Life* magazines are all very good sources for finding reference material.

I also photograph various subjects I may need at a later date for illustration backgrounds. Photographs taken at the airport, rodeos, air shows, and parades can be invaluable if an assignment comes up that requires this type of material. I make contact prints of these negatives and file them away. When traveling, I shoot a great many 35mm color slides and have found them to be an excellent source of reference material, especially for backgrounds.

Certain subjects, such as automobiles, ships, and aircraft, are well covered photographically in many books available in your public library. Some libraries have extensive picture collections that are very helpful for the artist. As I'm very interested in aviation, I have a very large collection of aircraft magazines and books and can locate most any avia-

Brushes should always be rinsed well after use with ink or paint, and they should occasionally be washed in water with mild soap. To wash a brush in soap and cold water, rub the brush in soap and clean the brush in the palm of your hand until all the dried ink particles are removed. When finished, rinse the brush thoroughly in water. If you leave ink or paint to dry in a brush, the brush may be permanently damaged.

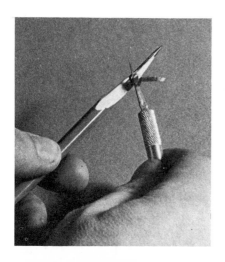

Use an X-acto knife to cut the wood from the lead, top, and a sanding block to sharpen the lead, above.

tion subject needed. If you need photos of people, you can shoot pictures of friends or members of your family. Occasionally I'll set the camera on the self-timer and shoot pictures of myself in the poses required. You can also hire professional models through model agencies — the agencies have composite books from which various types of models can be picked.

There are firms that specialize in stock photographs, and they have thousands of photographs available on countless subjects. And frequently, used book and magazine stores carry old Hollywood movie promotion photographs taken from the films. You can find great shots of cowboys, battle scenes, old ships, and other oddities in these promotion pictures. Another source of reference for certain subjects are hobby shops. They carry many finely detailed plastic model kits of aircraft, tanks, automobiles, ships, submarines, and guns. After you assemble these models, you can photograph them at any angle. All this may sound like a lot of effort, but finding the proper reference is really worth whatever work is necessary. You can't simply guess or try to remember what a certain subject looks like—you must know.

I have to photograph much of the reference material I need specifically for particular assignments. Many times it's much easier to shoot the reference photos than to look through hundreds of magazines for a certain subject. And, if you're a working illustrator, your clients may be able to furnish good reference photographs of their products.

CAMERA EQUIPMENT

For a great deal of my picture taking, I use the Polaroid 180 camera. This is an excellent camera, and I was fortunate to find a used one in very good condition. This model is without the automatic electronic exposure control found on many instant picture cameras—I prefer to alter the exposure if necessary. The great advantage of the Polaroid cameras, of course, is that you get instant results. When you're under the pressure of a tight deadline, this camera makes a lot of sense.

For most of my general photography, however, I prefer my Nikon FTn, an excellent and a very rugged camera. I have taken this camera everywhere. It has operated flawlessly in jungles, deserts, and other extreme weather conditions. I prefer the 35mm format because it offers a great range in the selection of available films — you can get 35mm color slides as well as both 20 and 36 exposure rolls. The 35mm reflex camera also has an advantage over a rangefinder camera — you view directly through the picture-taking lens and see exactly what you'll get on film. The Nikon FTn incorporates a through-the-lens meter/finder and has shutter speeds from one full second to 1/1000 of a second. I've enjoyed excellent performance from

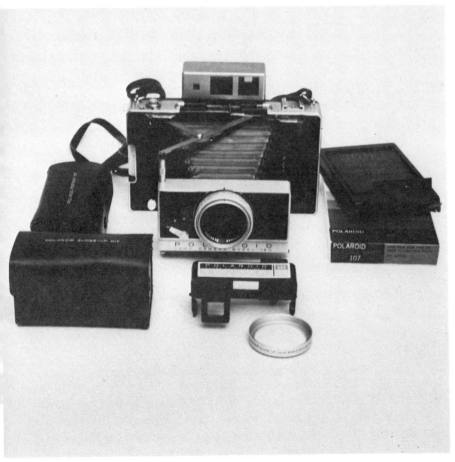

Above is an assortment of reference material gathered for an illustration involving a specific aircraft, a Brewster Buffalo. The plane is available in plastic kit form from a local hobby shop—it's easily assembled, and the finished model can be photographed in any view necessary. I found two publications (shown here) devoted solely to this particular aircraft. These books cover the plane in great detail with many photographs and excellent examples of variations in service markings. I also searched through other aircraft magazines and uncovered other material. It's surprising how much material you can come up with if you devote a little time to it.

Starting at the center and moving clockwise are: the Polaroid 180 camera; convenient film pack (and box)—you get eight black and white or color pictures, 3¼" x 4¼"/8.26 x 10.8cm; a close-up lens and finder to attach to the camera viewfinder; a close-up kit for extremely close-up pictures; and a portrait kit that includes a close-up lens and a finder to attach to the camera viewer.

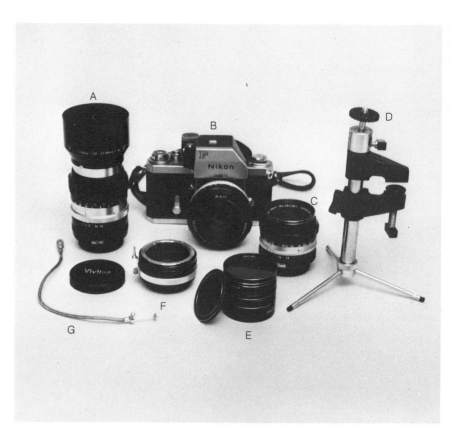

Here's the basic camera equipment I work with, especially when traveling: (A) 135mm f/3.5 telephoto lens; (B) the Nikon FTn 35mm camera, a reflex camera—you view your scene right through the picture-taking lens; (C) 24mm f/2 wide-angle lens; (D) a small, compact tripod—the legs can be removed and stored inside the tubular section, which is very useful when taking photographs requiring long exposures (such as night shots or very low light situations); (E) different color filters and close-up lenses screwed together, a compact unit to carry with you—the outer filters are protected by top and bottom caps that screw on; (F) a 2X teleconverter that turns my 135mm telephoto lens into a 270mm lens; and (G) cable release used when the camera is on the tripod—it ensures that the camera won't move when using long exposures.

this camera and consider it to be one of the finest on the market.

My lenses consist of a 55mm f/1.2, which is an extremely fast lens — very good for taking pictures under poor light conditions — a 24mm wide-angle, and a 135mm telephoto lens. When traveling, I find the 24mm wide-angle lens to be perfect for most subjects, such as people, buildings, marketplaces, and panoramic shots. The telephoto, a moderate 135mm, is sufficient for most long shots, and I found it to be perfect for shooting pictures of wild game on an African safari. I use my 2x lens extender with the telephoto when I want to convert it into a more powerful lens. The extender converts the 135mm lens into a 270mm, and the results are excellent.

I always carry a very small, compact tripod and a cable release for the long time exposures required for dawn, dusk, and night photos. In addition, I sometimes carry a hand-held meter to check the built-in camera meter when I'm on a trip. If I'm shooting color film, the exposure must be very accurate, and double-checking your camera meter can be good insurance on an important assignment.

When I don't want to carry around a heavy load of camera equipment all day, I take my lightweight Rollei 35. This is a compact, full-frame 35mm camera that is a precision piece of equipment, capable of taking excellent pictures. Its lens is a relatively slow f/3.5 and is not interchangeable. However, it is sufficient for average outdoor lighting conditions. The Rollei has a built-in light meter and shutter

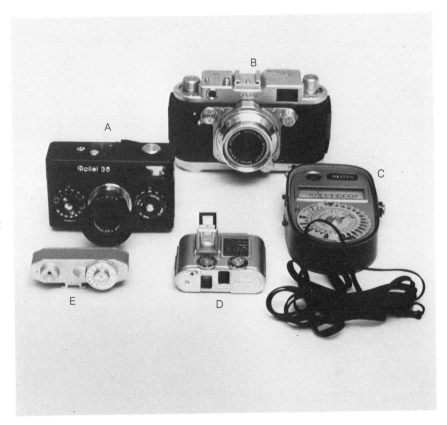

Some other cameras I've used: (A) the compact Rollei 35, a small full-frame 35mm camera made; (B) the Robot Royal 36, an automatic sequence camera with a spring motor that can take up to 6 pictures per second; (C) a light meter, necessary to compute exposure times—black and white films have a wide exposure latitude, but color film is very critical and you must use a meter to determine the exact exposure; (D) the Tessina, a very small, spring motor-driven camera that can easily be carried at all times; (E) a rangefinder, which is used to measure distances accurately—I sometimes use the rangefinder with the Rollei 35, as the camera isn't equipped with one.

speeds of ½ second to 1/500 of a second. This is the smallest full-frame 35mm camera made.

Another very interesting camera is the miniature Swiss-made Tessina, which measures 2⅝" x 2" x 1"/7.69 x 5.1 x 2.54cm. It uses 35mm film in special cartridges with up to 24 exposures. The negative size is 14 x 21mm rather than the standard 35mm negative size of 24 x 36mm. This is a precision-made camera and can easily be carried with you at all times. The Tessina has a 25mm f/2.8 lens and shutter speeds from ½ second to 1/500 of a second. The spring motor-driven film transport also cocks the shutter, enabling you to take pictures very rapidly—you can make excellent blowups from this camera's sharp negatives.

For taking sequence pictures in the larger 24 x 36mm format, you can attach an electric motor drive to the Nikon, or you can use a special camera made for this purpose. The Robot Royal incorporates a rapid-wind spring motor that permits taking pictures in rapid sequence. You can shoot up to 5 to 6 photos per second and take 20 exposures without rewinding. It's a great camera for taking pictures at auto races or sports events.

An inexpensive camera will serve you nicely at the beginning. In time, if you feel a real need for a more advanced camera, you can choose from a wide range of new or used cameras until you find one that is exactly suited to your needs. There's a great variety of camera equipment on the market—the cameras I mention here are just a few of the ones I've used over a period of years.

This brush drawing was one of a series done for an advertising campaign for Revere. It is a very carefully done drawing—all the lines in the water had to be spaced fairly evenly and of the same weight to be an even tone. I also had to curve the lines to promote the illusion of form in the glass. As it would have been impossible to imagine how the reflections and tones would look, I took some Polaroid pictures of a glass filled with water. Remember, when doing a difficult drawing, help yourself by finding or photographing the necessary reference material. I drew the seahorses from pictures found in the public library picture file.

150

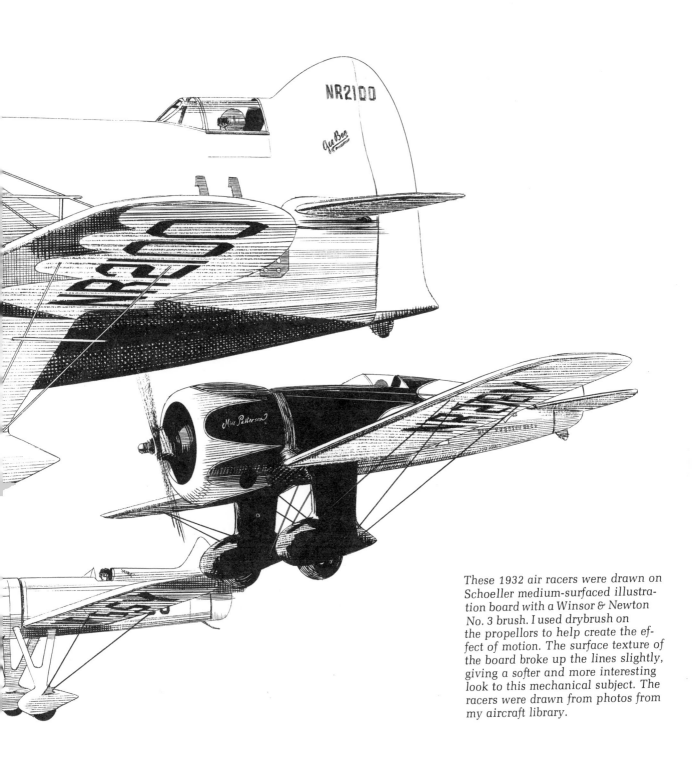

These 1932 air racers were drawn on Schoeller medium-surfaced illustration board with a Winsor & Newton No. 3 brush. I used drybrush on the propellors to help create the effect of motion. The surface texture of the board broke up the lines slightly, giving a softer and more interesting look to this mechanical subject. The racers were drawn from photos from my aircraft library.

Demonstration 14. Making a Graphite Tracing Sheet

The most widely used method for transferring sketches and drawings to illustration board is using the graphite tracing sheet, which is similar to the carbon paper used in typing. To use the graphite tracing sheet, you tape your drawing (done on tracing or layout paper) to the illustration board, slip the graphite sheet in between, graphite side down, and trace the drawing onto the illustration board with a stylus or a hard pencil.

Step 1. *Cover the surface of good quality tracing paper, 14" x 17"/35.56 x 43.18cm or larger if you prefer, completely with graphite by rubbing the sheet with a 4B or 6B graphite stick.*

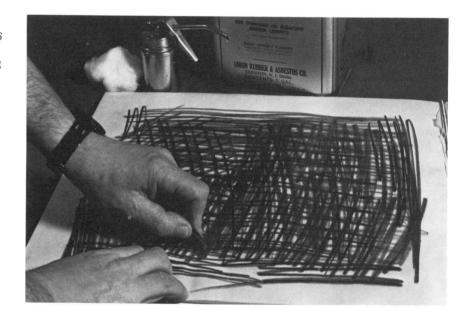

Step 2. *Dampen a wad of cotton with Bestine, a solvent used for thinning rubber cement. Be careful not to saturate the cotton, as the solvent may wash the graphite away, and you'll have to recoat the paper.*

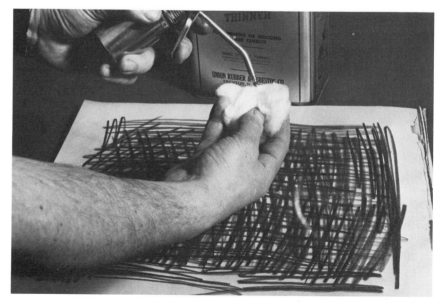

Step 3. Rub the dampened cotton over the graphite, dissolving it into a smooth and even black tone. You may have to go over the whole area two or three times to achieve an even tone.

Step 4. Once the surface has an even black tone, rub over the whole sheet with a fresh piece of clean, dry cotton. This will remove any excess graphite and produce a harder surface that minimizes smudging.

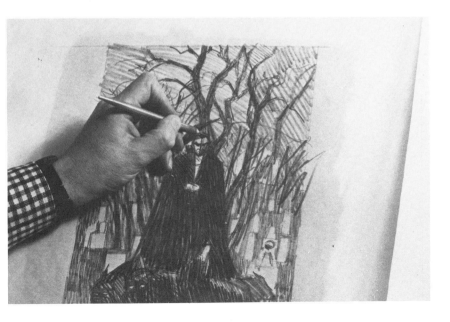

Step 5. Place the completed graphite tracing sheet face down between your drawing and the illustration board surface, and trace the drawing with a stylus or a hard pencil, such as a 4H. When properly prepared, the graphite sheet will produce clean, black lines. While tracing your drawing, be sure to lift the sheet occasionally to check if you've missed any lines. After the tracing is completed, you can redraw or correct any errors before starting the inking.

You can use this same method to trace photostats of photographs onto illustration board. Just coat the back of the photostat with graphite and go through the same process until you have a uniform, solid black tone. Tape the photostat to the illustration board and trace it with a stylus.

Demonstration 15. Projecting the Image

Many illustrators use an opaque projector for transferring drawings or photographs to illustration board. This can be a real time saver, as it eliminates the step of tracing a tissue drawing. The projector also enables you to enlarge or reduce your drawing easily. There are several models available, and the prices vary according to size and features. Check your local artist supply store or catalog for the models available in your area.

The projector I use is the Beseler Vu-lyte II. It can project a photograph or drawing that measures up to 10″ x 10″/ 25.4 x 25.4cm. Larger drawings can be projected in sections if necessary. I prefer to project drawings rather than trace them down, because I think the result is more spontaneous. I project the photographs right onto my illustration board and draw them with a pen or pencil. I also project small preliminary sketches up to actual working size.

My projector is mounted on a stand with wheels for easy movement. The farther back from your drawing board the projector is moved, the larger the image, and vice versa. In addition, the Beseler Vu-lyte II has a special attachment that lets the lens barrel slide out of its holder, reducing the projected image.

If you don't have a projector, you can use a 35mm slide projector to project color slides directly onto your illustration board for drawing. When working from color slides, you can use a tabletop daylight slide viewer. You can see the image quite well if you turn off your overhead lights and just leave on the lamp over your board.

Step 1. (*Above left*) *The Beseler Vulyte II opaque projector in position.*

Step 2. (*Above*) *This projector is equipped with a reducing attachment—the lens barrel can slide out of its mount on special, attached guides to reduce the size of the projected image.*

Step 3. (*Left*) *I put a sketch into the carrier.*

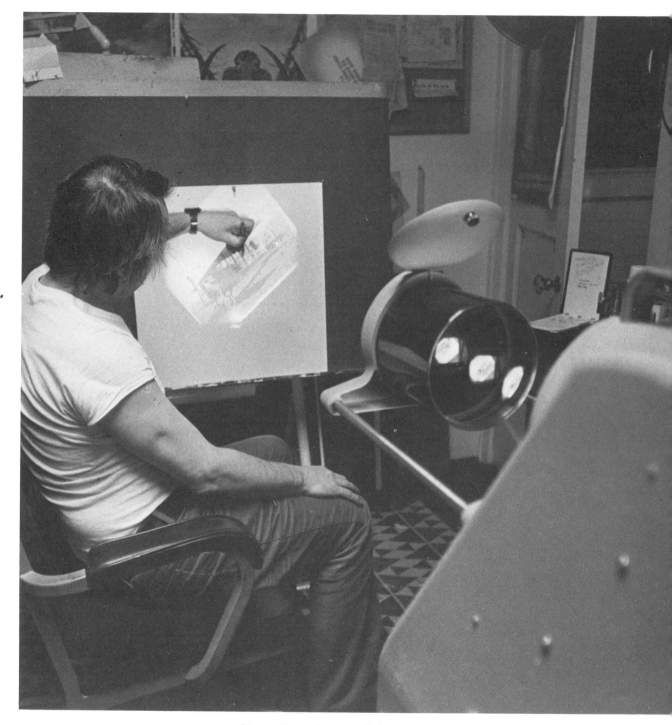

Step 4. *I turn the room lights off to get the brightest image and turn on the projector, projecting the sketch onto a surface tilted to a 90° angle. Whatever surface you project your drawing on to must be tilted to this angle—you can buy a drawing board that tilts automatically, which is very convenient.*

Bibliography

Fawcett, Robert. *On the Art of Drawing*. New York: Watson-Guptill Publications, 1977.

Guptill, Arthur L. *Rendering in Pen and Ink*. Ed. Susan E. Meyer. New York: Watson-Guptill Publications, 1976.

Hogarth, Paul. *Creative Ink Drawing*. New York: Watson-Guptill Publications, 1968.

_____. *Creative Pencil Drawing*. New York: Watson-Guptill Publications, 1964.

Pitz, Henry C. *Ink Drawing Techniques*. New York: Watson-Guptill Publications, 1957.

Taylor, Benjamin Debrie. *Design Lessons from Nature*. New York: Watson-Guptill Publications, 1974.

Watson, Ernest W. *Art of Pencil Drawing*. New York: Watson-Guptill Publications, 1968.

Index

Edited by Ellen Zeifer
Designed by Bob Fillie